The
Flower
Market
Year

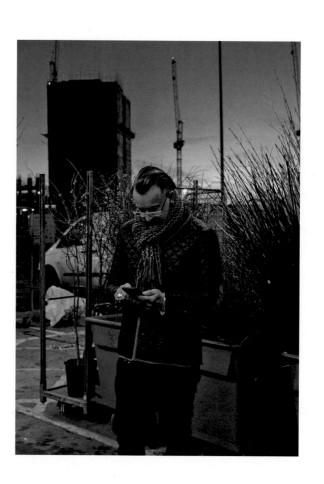

The Flower Market Year

Twelve months at New Covent Garden Flower Market

SIMON LYCETT

Photography by Michelle Garrett

The Flower Market Year
First published by Simon J Lycett
Ltd in 2019
Arches 270-272 Bethwin Road
London SE5 0YW

www.simonlycett.co.uk

Designed, edited and produced by
Berry & Co (Publishing) Ltd
www.berrypublishing.co.uk

Designer Steven Wooster

British Library Cataloguing in
Publication Data
A catalogue record of this book is
available from the British Library

ISBN 978-1-9160912-0-7

Printed in China

*To my BRILLIANT Team Lycett,
to Al, Covi, Jill, Jonny, Jude, Julia, Julie,
Leo, Miranda, Nicole and Ruth, who
daily give their talent and time, and also
to Mel, who did.
THANK YOU, I'm lucky to have you
all with me on this journey.*

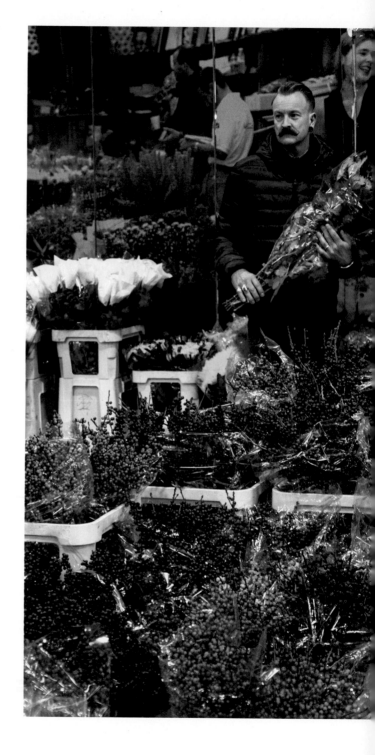

Introduction

ONE CHILLY OCTOBER MORNING in 1987, I made my first foray to New Covent Garden Flower Market in the company of the late Robert Day, for whom I had begun work as a junior florist. To this day, I can still recall the anticipation and excitement I felt at entering what was to me a true floral Xanadu, where stand after stand was filled with trolleys and tubs, boxes and buckets of flowers, plants and foliage in a seemingly unending assortment of colours and varieties.

As a 20-year-old Warwickshire boy, who had only visited London twice previously, everything was utterly thrilling and totally exciting. That first morning is indelibly stamped upon my mind because I was in the company of a man who was a floral hero and it was October, when the foliage colour was almost as dazzling as the buckets of dahlias and asters and the boxes of chrysanthemums. More than 30 years later as I write these lines, I can still smell it: the mixture of damp foliage, of chrysanthemums and of lilies, with an over-riding waft of cigarette smoke (for back then we all smoked everywhere!). The scents are still pretty similar, albeit without the tang of tobacco, as are the sights: for the cycle of the seasons is the generator that powers the Flower Market, which keeps us florists supplied and inspired.

While records as early as the 1200s make mention of a 'Convent' Garden, the market really began in the 1600s, when monks from the Abbey of Westminster began selling the surplus from their gardens. Perhaps the power of prayer improved their yields for soon a regular market sprang up, and in 1670 Charles II granted them a Royal Charter for their market at Covent Garden to take place each and every day except for Sundays and Christmas Day. By the 1800s the fruit, vegetable and flower market was doing a roaring trade as growers from around the country swelled the stalls with produce galore, to such an extent that by the 1840s a covered market had been constructed (which now forms part of the Royal Opera House). But Covent Garden Market eventually became a victim of its own success and by the 1960s the

6

site was causing chaos and congestion, with an increasing number of ever larger vehicles arriving and departing throughout the night and early morning. It was realized that another, less central site was needed, with excellent transport links in and out of the City. In 1961 the newly created Covent Garden Market Authority identified an area just south of the river, at Vauxhall, where a new fit-for-purpose market would be built. Eventually renamed New Covent Garden Market, the five-acre site started trading in 1974 and was officially opened in June 1975 by Her Majesty the Queen.

In the 1980s, with the innovation of swifter ships, planes and motorways, fresh deliveries from Holland and across Europe and beyond gradually began to arrive several times each week. Then the 'flying Dutchmen' arrived in Britain, with their vast articulated trucks laden with beautifully displayed flowers quite literally bringing the flower fields of Aalsmeer to the doors of many high street florists and shops. By 2006 the Market Authority realized that a newer, slicker Market was required and the plans were finalized for a new combined Fruit, Vegetable and Flower Market. Building began in 2015.

Aware that the 'old' New Covent Garden Flower Market, a building and an institution I had come to know and love, was to be demolished, I decided to document this historic change. The incredibly talented and quietly brilliant photographer Michelle Garrett, with whom I had worked on a few of my previous books, agreed to be my photographer. Over the calendar year, she spent a couple of days a month photographing the Market, sometimes just the flowers, often me and what I was buying, but also capturing a real sense of the the place, with its salesmen and women, customers and porters, buyers and suppliers. I realized that what Michelle was recording was the gentle but unstoppable evolution as the seasons progressed month by month, so the flowers I was buying and using became an actual calendar of the floral year. Here is what we captured, what I saw and bought, what inspired me and how I used it to create floral decorations which truly were seasonal: in all, exactly what it says on the tin, *The Flower Market Year*.

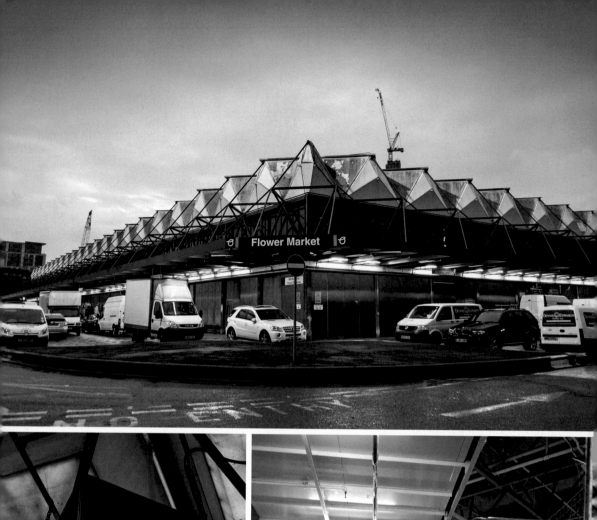

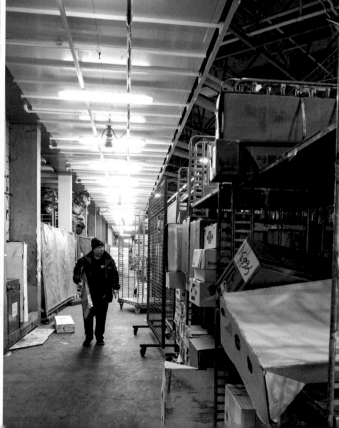

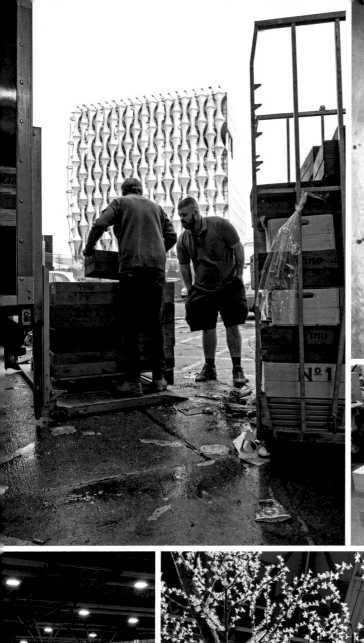

Taken on my mobile

My iPhone is nearly always in my hand when I'm at the Flower Market, so I can capture what's around and looking gorgeous, often sharing these images on social media, which, in turn, helps to support the Market. Thirty years after first coming to the Flower Market, it still inspires me!

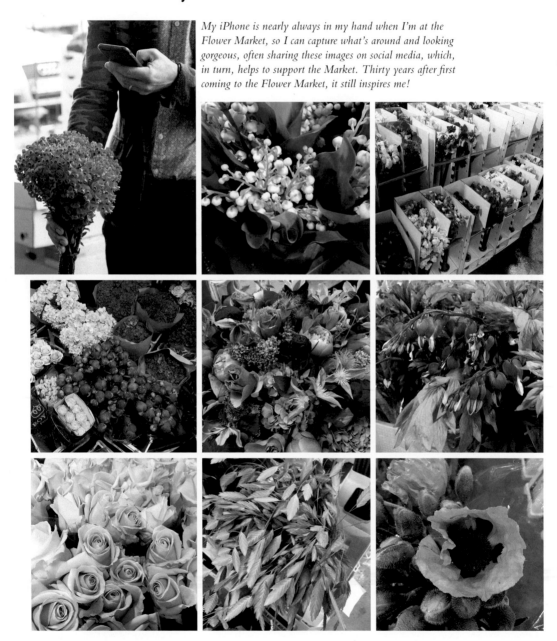

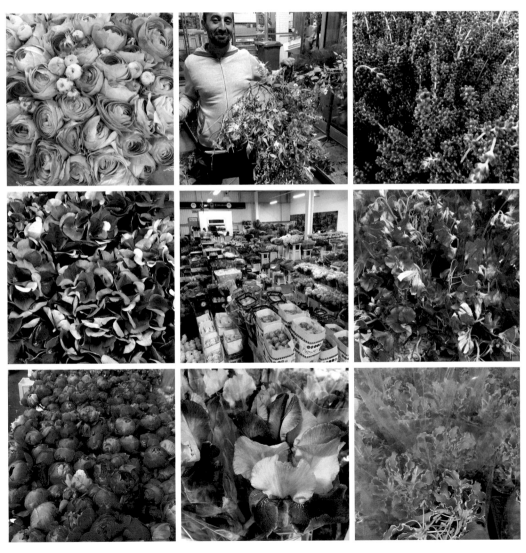

January

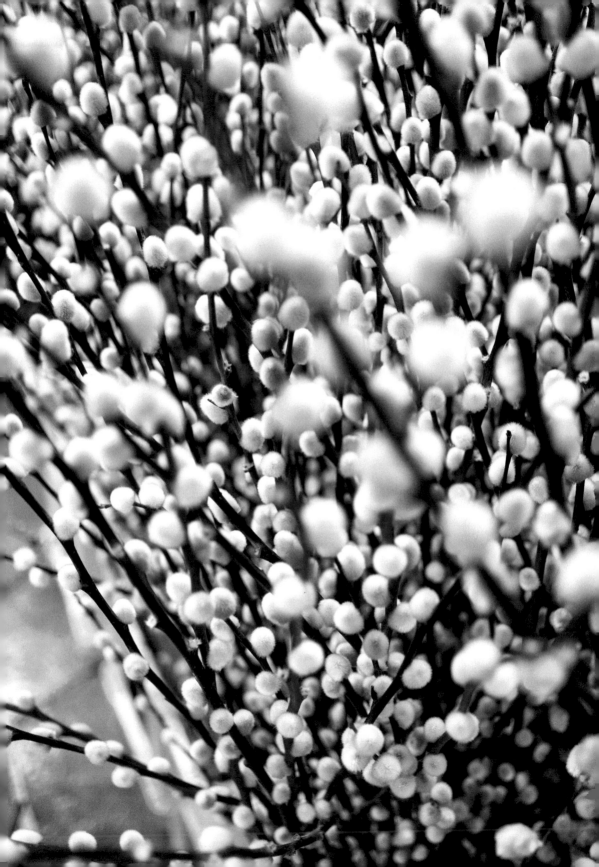

LOVING NEW COVENT GARDEN FLOWER MARKET as I do, it still
seems an effort to face waking to an alarm after a few days
off between Christmas and New Year. Usually it's cold and grey,
with little to inspire at the Market other than a spot of banter
with the salesmen and women. Knowing only too well that
tired bundles of holly and glitter-encrusted twigs will be lurking
in forgotten corners (like fancy-dress contestants who got the
date wrong!) and that bins will be overflowing with discarded
Christmas trees and lengths of brittle pine garland, the only hope
is of a few early spring blooms! Heavy soulless slabs of amaryllis
buds packed in their slender cardboard coffins seem to
cast reproachful glances at the showy leftover cartons
of bright baubles and bunches of gold-dipped magnolia
leaves. All in all, not much lures me from my bed in
these first days of January. But with a desire to get back
into a routine, I pop into the Market just after New Year
and unexpectedly there is a great buzz, with lots of folk
buying from a plentiful assortment of flowers, with much
more colour and variety than I had expected. Sometimes
it's great to see the seasons being cheated just a bit! While
daffodils and scented narcissus will be doing their thing
in a few weeks time, for now I just need a few stems to
gladden the heart.

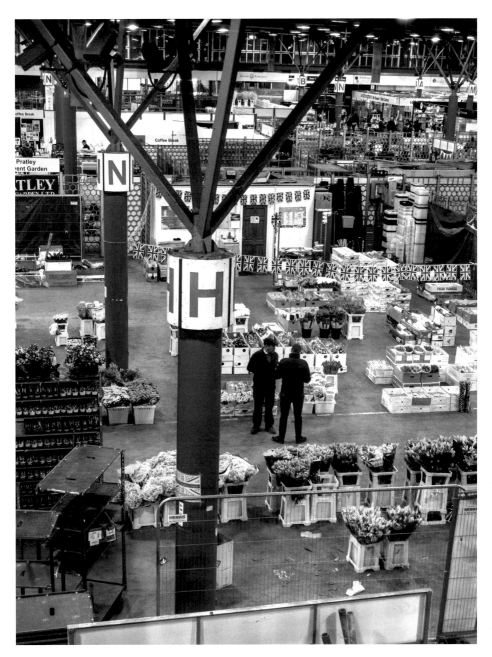

In early January, New Covent Garden Flower Market
tends to be a bit of a ghost town, with some salesmen taking
the opportunity to have a few weeks of post-Christmas
rest while others catch up on chores neglected during the
December rush.

Just blossom

Sometimes floral decoration is just about combining the right container with the right plant material, and this couldn't be better illustrated than by these gloriously fragrant stems of *Viburnum × bodnantense* which I happened upon at one of the foliage suppliers who specialize in British-grown produce in the Flower Market. One of the endearing charms of a visit to the Market is the serendipity of what is sometimes on offer. Not always (and rarely when you really desperately need or want a few stems of magic) but often when least expected, you will spy some stems or bunches of real treasures, lurking in a bucket in a hidden corner. As I am a regular, some suppliers will keep special things to one side in case I can use them – a lovely reward for being a loyal customer. During the quieter months at the start of the year, the treats are few and far between, as trade is slow and quiet, especially among the foliage suppliers who are still recovering from the past two months of pine- and glitter-filled excess, and who generally don't have much on offer in January other than boxes of US-imported salal and Israeli ruscus or bundles of pussy willow and dogwood, with bundles of Cornish camellia and branches of catkins adding occasional interest.

Having snaffled these beautiful viburnum stems, I knew that they would look perfect just 'plonked' in a simple vase. The one I chose is actually an early 19th-century apothecary's leech jar! I have a few of them and while they look stunning empty, they can be a challenge to use as a vase, as the wide opening and shallow bowl mean that most stems tend to slump to one side. But with these viburnum branches it was the perfect way for them to behave, and meant that the beauty of the flowers and the vase combined to simple and glorious effect.

The simplest of stems gently placed in an understated container creates something so much more than the sum of its parts.

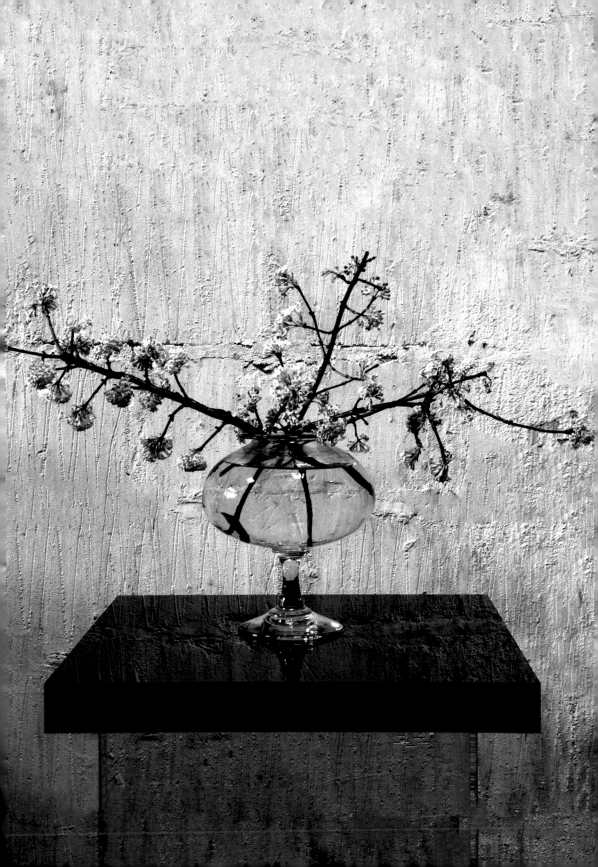

1

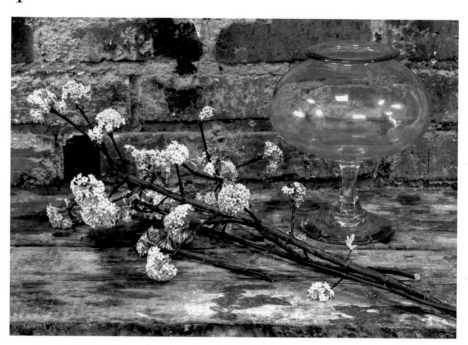

*Assemble your plant material and chosen vase. Fill the
vase two-thirds full of water. Remove lower branches and
leaves from the stems as you cut them to the desired length.
It's a good habit to cut stems on an angle, and to make a
small split half an inch or so up woody stems to help the
uptake of water.*

2

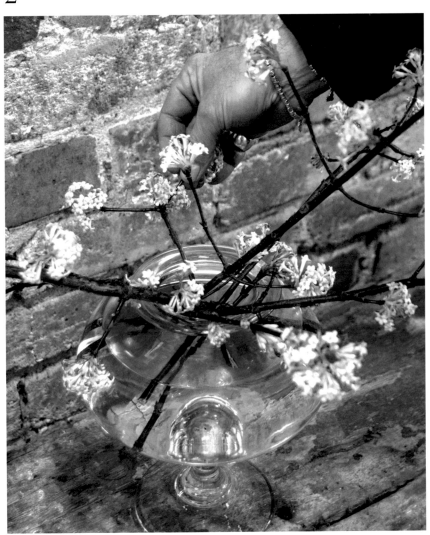

Branches as glorious as this Viburnum × bodnantense *need no skill to arrange – just patiently place them into your vase, letting them rest where they are happiest and gradually add in other stems until you are pleased with your decoration. Reflect the manner in which the branches grow and don't overcrowd them. Occasionally less is more!*

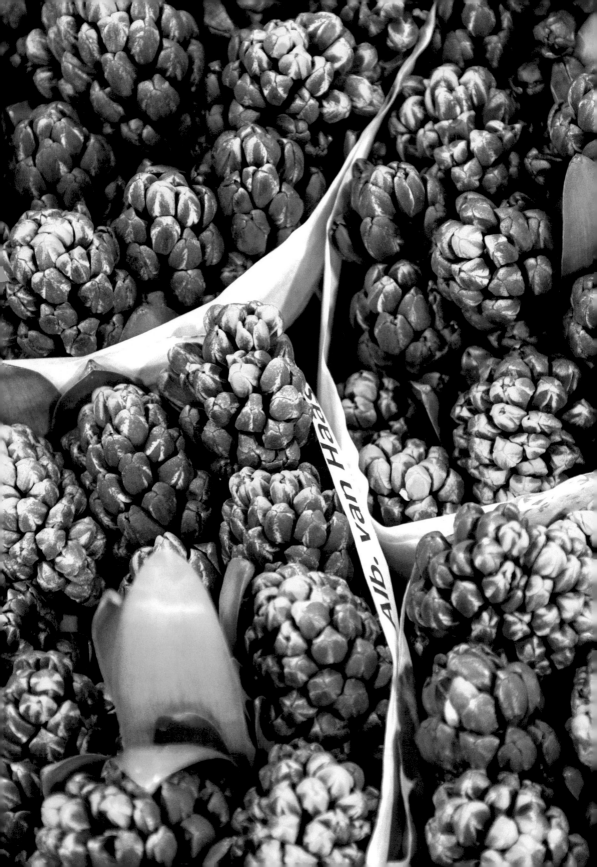

OPPOSITE *There is something wonderfully pleasing about the manner in which different flowers are packaged, supporting and showing them to their best advantage. Hyacinths are almost always sold in weighty bundles of 25 stems, bound with rubber bands and white paper to keep them tidily together, a perfect foil to the almost asparagus-like, immature flower stems.*
ABOVE *Iris frequently arrive into Market like pencils, showing the merest hint of colour in a sheath of silvery green, but these have a sculptural quality in their matching shades of purple and green.*

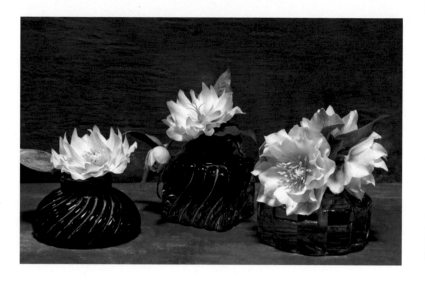

Hellebores

The adored-by-flower-clubs flower-arranger George Smith, awarded an MBE 'for services to flower arranging', once told me that hellebores enjoy being conditioned in gin. Though a whisky drinker myself, it still seems a waste of spirits, so I usually arrange these gloriously understated blooms in water. For garden-grown hellebores, miniature vessels are ideal containers as its often tricky to achieve much stem-length, unlike the Italian-grown bunches of them that appear in the Market from December to early May.

Unfortunately hellebores wilt pretty swiftly no matter how diligent the conditioning. Cutting the stems at an angle rather than straight across exposes a greater surface area, maximizing their chances of taking up water. Despite this, I find they still often droop a day or so after arranging and, if this happens, re-cutting the stems and putting them into hand-hot water will often perk them up for a few more days. If they become sulky again, I behead them and float the flowers, gaining a couple more days' enjoyment from these truculent treats.

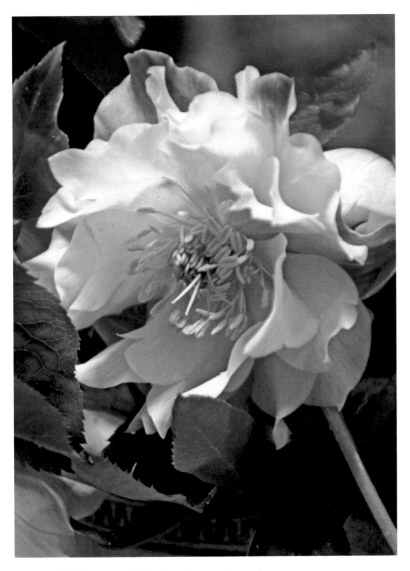

OPPOSITE *Hellebores are a bit shy, but when cut short and popped into vessels like these old French inkwells their true multi-petalled perfection shines out.*

ABOVE *The layers of petals in hellebore flowers are sometimes speckled or gently shaded in mauve and purple or, as here, in greens through to white – a perfect counterfoil to the clusters of pollen-drenched tassel-like stamens.*

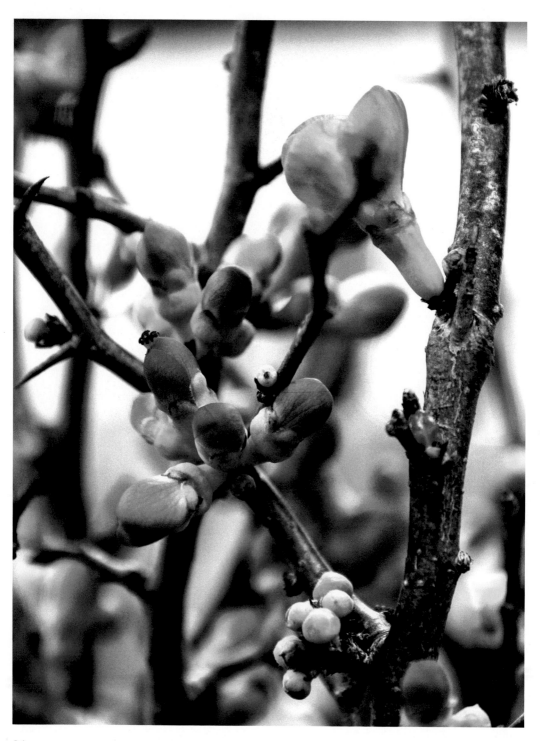

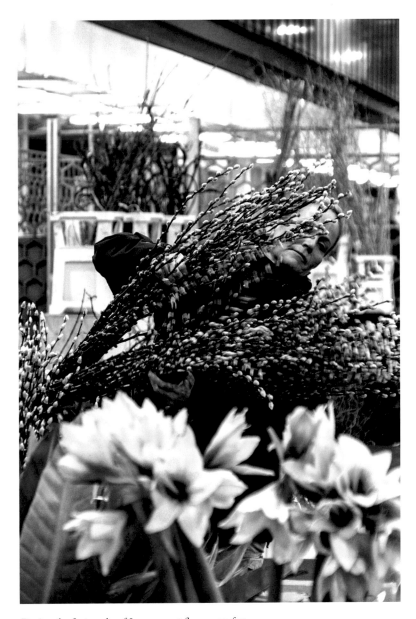

*During the first weeks of January, cut flowers are few
and far between, and for those fulfilling their New Year
office and hotel flower contracts, bunches of japonica
(OPPSOITE), pussy willow and amaryllis (ABOVE) are firm
favourites for many post-Christmas arrangements.*

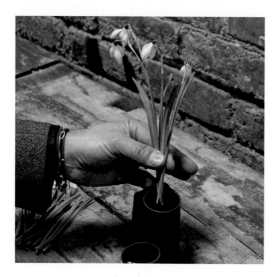

Simply snowdrops

As a child growing up in Warwick, I walked to and from school, and on the way home would take a short-cut along Warwick Castle driveway. The start of the January term usually saw a few heavy snowfalls or wonderful crispy white frost lasting for several days. I can clearly remember, as a teenager, the joy of seeing clumps of snowdrops peeking out above the snow, thrusting their optimistic buds bravely above the icy parapet. Even now, nothing gladdens my heart more than drifts of these delicate but doughty little blooms, flowering their snowy little heads off.

Luckily these bunches of British snowdrops were saved for me and it was an utter joy and a total treat to create these simple 'plonks'. Their elegance is such that they look wonderful when you allow the beauty of the flower to be enjoyed in as natural a style as possible. Usually bunches of snowdrop flowers are sold with their own leaves, and sometimes also with a little 'frill' of ivy leaves. I find the ivy leaves are too heavy for the flowers and prefer their natural grass-like foliage.

When arranging spring bulbs you will find they are always happier if the stems are cleanly cut and arranged in fresh water. They are not really fans of flower foam. As with most spring-flowering bulbs, they are thirsty, so keep an eye on water levels and top the vases up regularly.

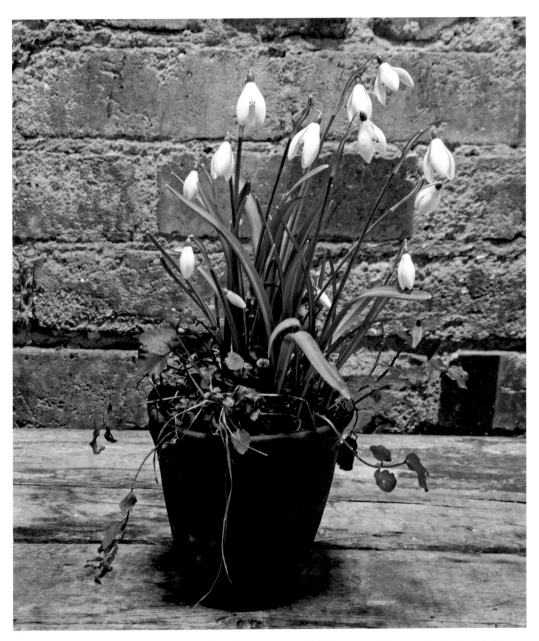

OPPOSITE *If you are lucky enough to spy some bunches of cut flowers, or the rather lanky forced pots of growing snowdrop bulbs that we see in January in the Flower Market, separate the flowers from any added foliage and, having re-cut the stems, simply 'plonk' them in a simple narrow vase or two.*

ABOVE *The joy to me of the snowdrop is that it looks perfect either when growing or very simply displayed. If your friends grow snowdrops, why not ask if they would liberate a trowelful and pop them into a terracotta pot to be enjoyed indoors for a few days before returning them to the garden – either yours or the kind donors!*

February

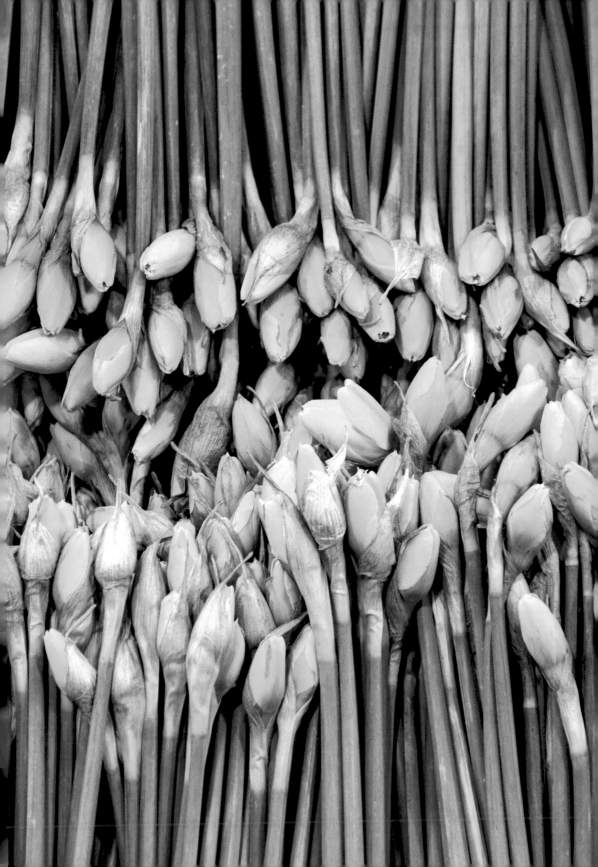

I WANDER AROUND THE MARKET feeling rather smug during the
'Valentine' season. Having no retail outlet at Simon Lycett Ltd,
we are able to escape the high-street demands for single red roses,
bunches of 'anything as long as it's red' and bouquets smothered
with acres of kiss-covered cellophane and yards of plastic ribbon
curls. For weeks before the main event, the market stands slowly
turn redder and redder, as Valentine-themed products and
packaging, designed to melt even the hardest of hearts, take over
– almost more so than at Christmas, which at least is alleviated
by a bit of glittery sparkle and green spruce. Papery hyacinth
bulbs, sending up chunky green nipples of flower-filled buds, pert
'Tête-à-Tête' narcissus and even elegant bobble-ended muscari all
come with huge helpings of schmaltz. Crimson pots with 'love'
scrawled upon them in seven European languages now hold green
helxines which two weeks earlier looked far more
enticing and comfortable in their homely brown plastic
pots. Sticks with fuzzy-flocked hearts on the ends are
stabbed into the most savage of cacti or the ugliest of
succulents. I often wonder who buys them, and what
the reaction is of their recipient. No manner of red
tissue and nylon lace would ever make me feel any more
amorous towards someone who presented me with a
spiteful, ugly and phallic cactus plant. Give me a pot
of miniature cyclamens, or a glossy-leaved gardenia all
a-glow with lime-green spiralled buds and I will love
you forever! And, please, never send me a bunch
of red roses on Valentine's Day! Almost any other time
of the year they are fine, and often very beautiful too –
an excellent demonstration not only of perfect

*Red roses arrive in the
second week of February
and sit, bland within their
buckets, with the romantic
hopes of London's single
and unattached weighing
heavily on their shoulders,
before being crafted into
bouquets and despatched
in hope and expectation.*

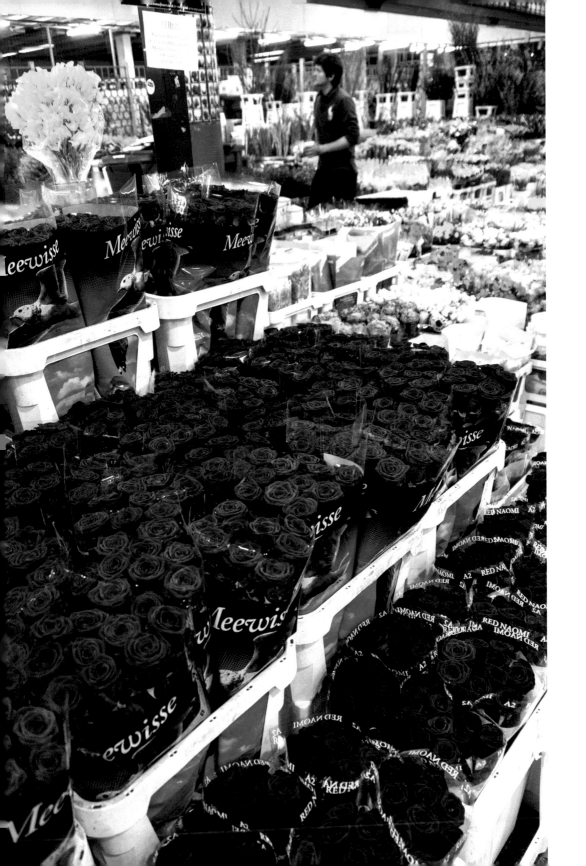

love but of the nurseryman's art and skill in achieving 3ft/1m
of perfect thornless stem topped by vast cabbage-like heads of
deep and velvety petals. However, with heightened demand,
many have been stockpiled for several weeks in cold storage by
less scrupulous growers and dealers, so it is often hard to tell
just how old they really are. I always advise the half-dozen or
so of our clients for whom we send Valentine's arrangements
that there are masses of flowers far more beautiful than roses to
be given. Fragrant narcissus from the Isles of Scilly, flamboyant
parrot tulips, decadent lilac, and plump ranunculus are at their
finest in early spring, so let's save roses for the summertime. My
own Valentine received from me a simple tied posy of lilac-shaded
hyacinths and short citrussy green guelder rose, with a heart that
I had woven from red dogwood stems stuck into it. No gift wrap,
no ribbons – just lovely fresh flowers, simply presented.

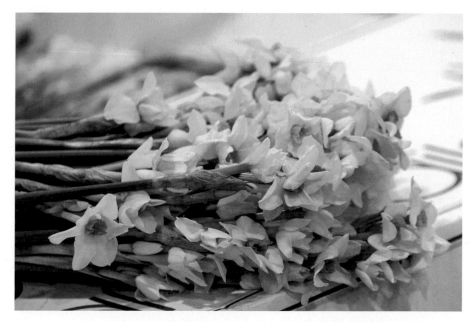

February sees spring flowers arriving in earnest at the Market, from humble boxes packed with scented narcissus (ABOVE), shipped from the Isles of Scilly, to the French parrot tulips, the very zenith of chic, petalled perfection (OPPOSITE). Through clever breeding, like aristocrats, they have become rarefied and glamorous and, like many grand ladies, they travel sheathed in a veil to protect their heads!

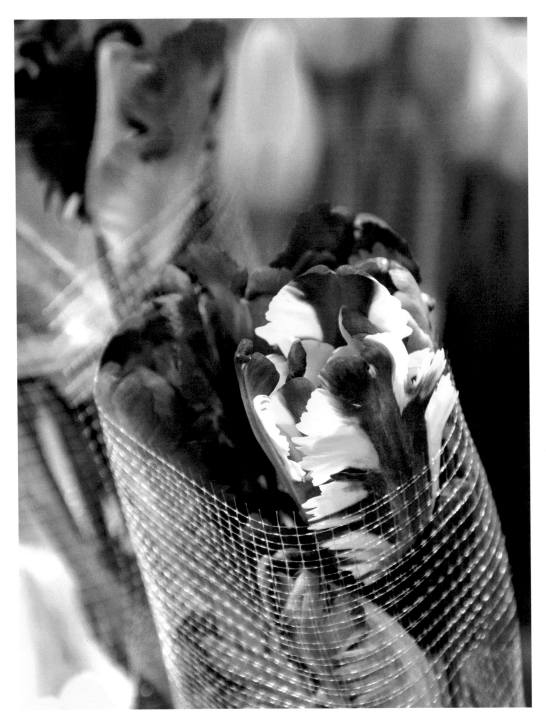

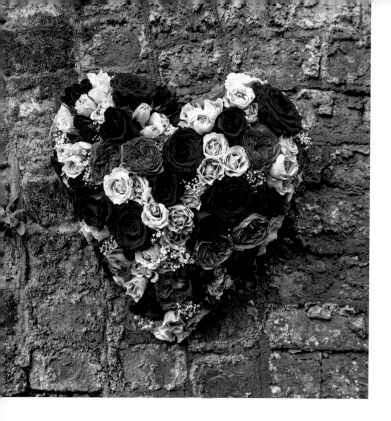

Rose heart

When about 12 years old, I borrowed from the local library a flower book, I think by Pulbrook & Gould, which featured a mossed heart base into which hundreds of violets had been wired. To a budding florist from Warwick it was possibly the most inspirational Valentine arrangement I had ever seen. This being the 1970s, the local flower shops sold a pretty unsubtle assortment of heart-shaped plastic products for any amorous locals. Often what had been on display in late January and would be again in March were the same items and arrangements, but with quilted satin sashes inscribed 'I Love You' draped around them. Maybe that's what the flower-buying bloke of the 1970s wanted, but to me it all felt deeply soulless. So here, inspired by that first vision, still as fresh in my mind's eye some 40 years on as it ever was, is what I might choose to send to my Valentine. Recreated from mixed rose and spray-rose flowers, each one is mounted on florist's wire and inserted into a base of damp moss (to sustain the blooms for a few days before it all dries to become a treasured momento). Such a design, scaled up or down, becomes a delicate pillow of perfumed, petalled perfection or a voluptuous vehicle for a message of amorous intent.

Small stems of mixed pink and red spray roses, in an assortment of varieties, become a wonderfully decadent, romantic ruffle of colour and love when massed together on this mossed heart base.

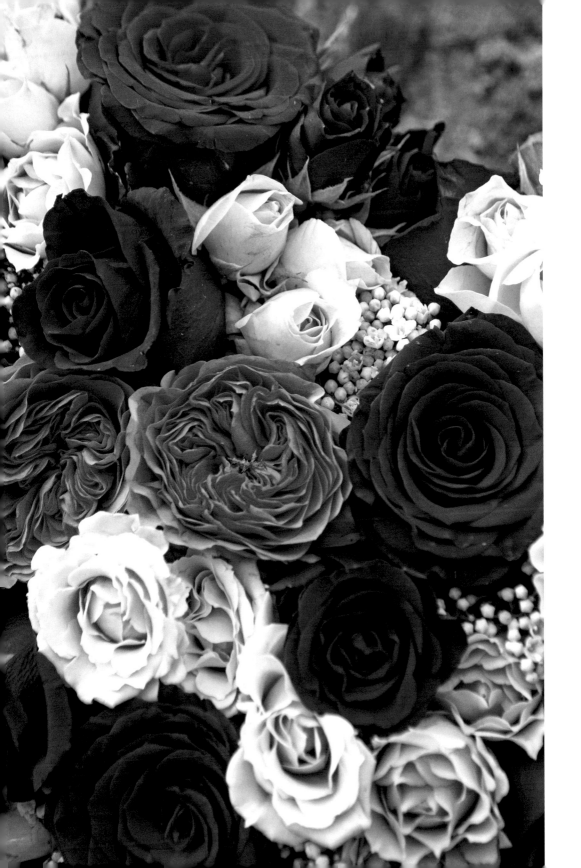

1

I have used damp moss and 2in/5cm mesh chicken wire to create a rough heart-shaped base to which assorted flowers and foliage sprigs are secured with wire. The damp moss will sustain the plant material and, with gentle misting from a water sprayer, the flowers will last 4 to 5 days.

2

Start by placing the teased moss (from which any roots and branches have been removed) upon a square of wire, cut to twice the size that you wish your finished base to be. Fold the sides over initially to form a trianglular shape, and add additional handfuls of moss to form a central dome effect.

5

Select your chosen flowers and trim the stem length to 2in/5cm long, and, using florist's stub wire, insert it beneath the flower head and then draw the two lengths of wire together.

6

Twisting one wire over the other, trapping the natural stem in position to secure the head, cut each stem short, leaving a sufficient length to protrude into the damp moss to sustain it. Repeat with the remaining stems.

3

To create the curved 'top' of the heart, use sharp florist's scissors to cut into the centre of the upper side of the heart and bend these two 'wings' downwards to create the V-shape, binding them in place with reel wire.

4

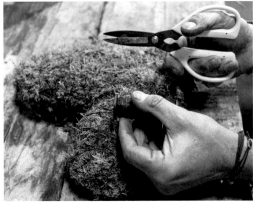

With reel wire and additional moss, bind a few additional handfuls of moss to create a roughly symmetrical and pleasingly plump base, with a suitably cleavage-style profile at the top. Generously water the base and set to one side to drain.

7

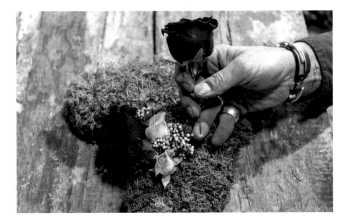

Insert the wired stems into the moss base, pulling the wire out onto the reverse of the base and then threading it back in to ensure it supports the flower and so no wires protrude at the back. Continue until the base is covered fully, and has a generously curved appearance.

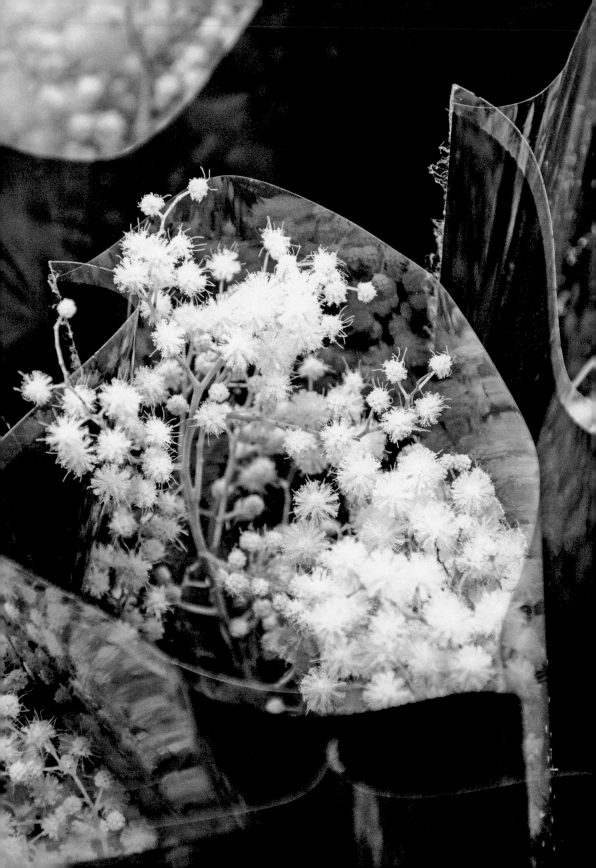

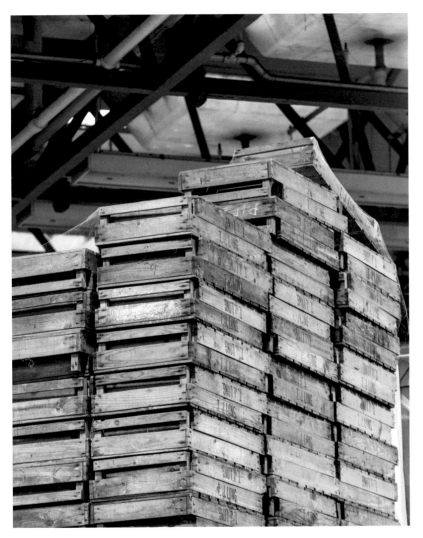

OPPOSITE *One of the first February treats is the arrival of the French mimosa, usually sheathed in cellophane to preserve some moisture. The unprepossessing buds open to become the fluffiest of Easter-chick flowers, drenched in pollen and perfume.*
ABOVE *At this time of year wholesalers maximize their revenue options, tempting us florists with an array of accessories, including this spectacular stack of old wooden crates, perfect to display decorations or plant up with summer salads and herbs.*

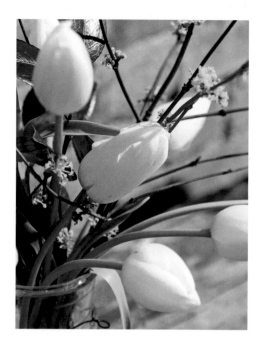

Tulips in glass jars

One of the many joys for me of buying from the Market is that every time I go is like a Lucky Dip day – because you never quite know who will have what. There is, inevitably, an abundance of the 'usual' items (and immediately I have typed that word I feel guilty for taking for granted the almost daily access to such a lavish assortment of wonderful flowers) but there is often a bucket or a bunch of something that stops me in my tracks. Sometimes I buy immediately, but often I will just take a few pics, post them on Instagram and revel in the excitement of the varieties available. Other times I want the entire bucket or bundle! Usually, the first French tulips that arrive into Market in early February are the sort of flowers to lure me to their side. Immaculately and slimly packed in wraps of ten, they stand head and shoulders above the more gutsy paper-sleeved bundles from Holland. The flowers are protected by a wonderful veil-like shroud of nylon. Knowing these glamorously presented beauties hail from Nice is no surprise – they look fit and ready for the Cannes catwalk!

*The beautiful glass vases (*OPPOSITE*) are, in fact, French grape jars, complete with the original wires that were used to suspend them beneath the vines, supporting and protecting the bunches as they developed. Filled with water, they are the perfect receptacle for a few elegant tulips and accompanying witch-hazel and camellia foliage.*

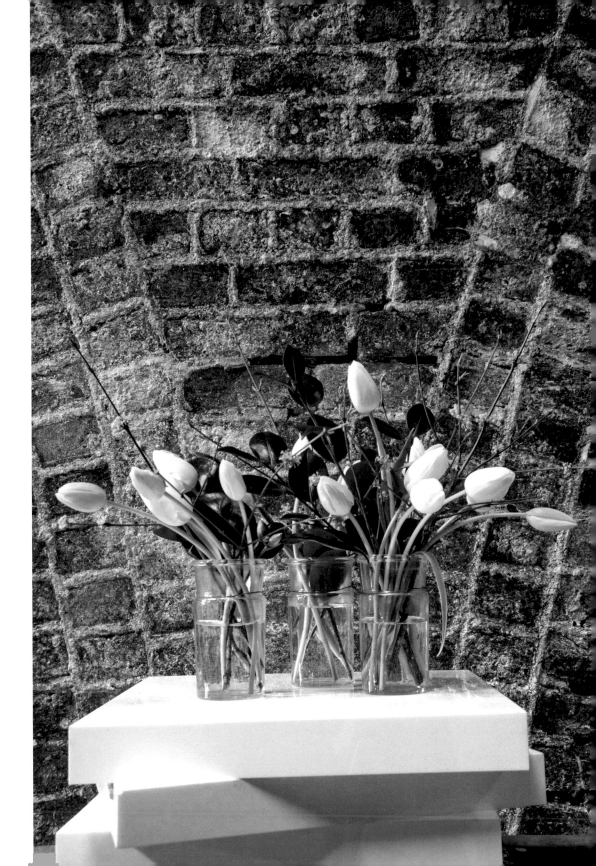

1

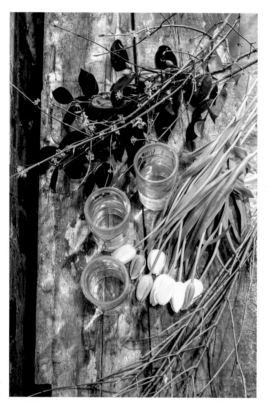

2

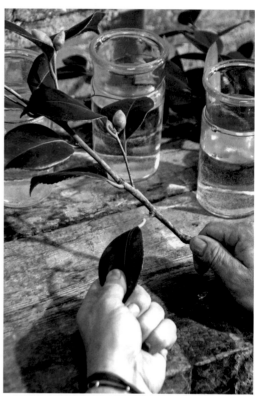

Assemble your plant material and chosen vases or vessels. Fill the vase two-thirds full of water. A wrap of French tulips together with a few stems each of witch-hazel and camelia foliage will easily fill three vases.

Remove any lower leaves from the stems as you cut them to the desired length to ensure that the water stays clean and clear. Remember to cut woody foliage stems on an angle, to help them take up water.

3

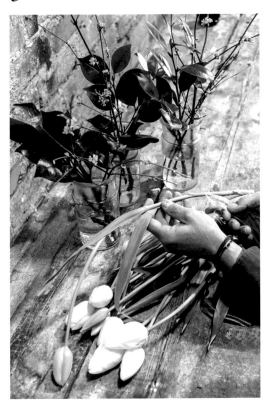

4

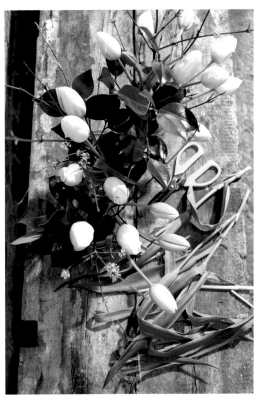

When arranging a few stems in relatively small vases, strip off some lower leaves from the tulips, as they can overcrowd the vases and will also swiftly turn clear water into soup!

As you arrange the flowers and foliage in the jars, bear in mind their final position. To avoid the decoration becoming too crowded, leave some space for space!

March

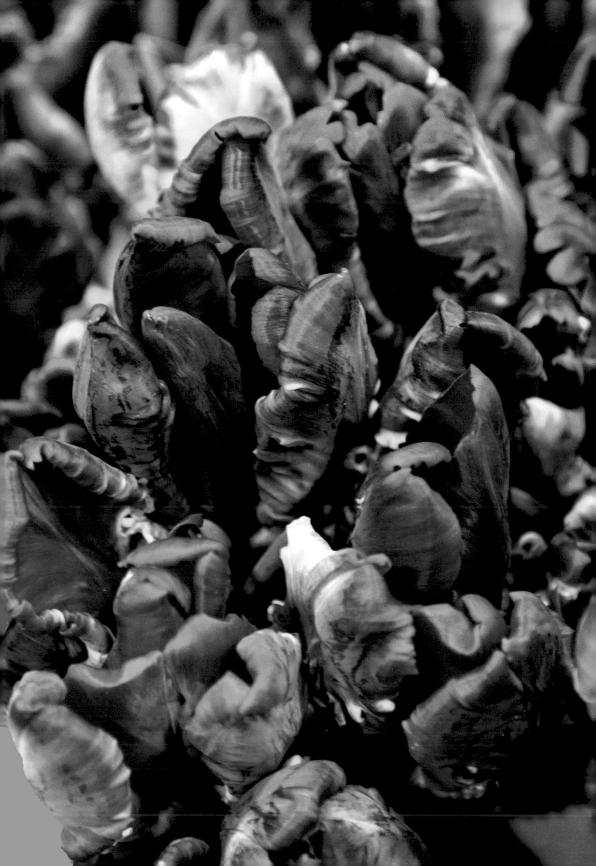

IT'S IN MARCH that the Flower Market starts to look and feel 'full' again, after a rather sparse start to the year. At last, almost every stand is bursting with colour, and the predominance is, unsurprisingly, made up of spring flowers! Rows of shallow bins containing hefty hyacinths, their unopened buds reminding me of asparagus spears, sit between wraps of ranunculus, a relative of the buttercup, which is why I always think the yellow ones seem the most acceptable. While some folk rave over them, ranunculus are possibly my least favourite spring flowers, as a promise-filled bundle of them swiftly become a straggly and underwhelming armful when freed from its wrapping. Of course, I'm not including the precious Cloni (or Cloney) family – a relatively new kid on the block – in this criticism, as the Cloni forms are

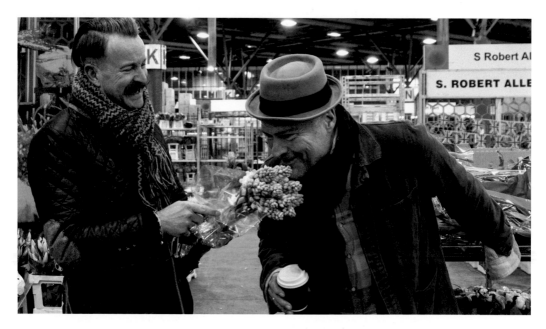

much larger of head, although in a more limited colour palette than the standard varieties. They are twice the price but are a wonder to behold. More paeony than buttercup, their layer upon delightful layer of petals form flowerheads the size of burger buns, in a mélange of shades that vary from wafty wedding tones to bright boiled-sweet colours. Where the ranunculus and hyacinths aren't, the tulips and the narcissus most definitely are! There are literally thousands of flowering bulbs as far as the eye can see. Wrap after paper wrap of tulips, in a spectacular riot of colours, nestle into shallow tubs. Presented by some wholesalers in satisfyingly neat, tidy, colour coordinated groupings, on other stands they form a chaotic mish-mash, no less pleasing to the eye, as if a vast bag of wine gums had just been spilled across the floor of New Covent Garden Market.

To this day, the Dutch still lead the world in the development of tulips although there are now some wonderful British growers producing a glorious bijou assortment which always arrive into the Market in pristine white cardboard boxes. I'm particularly drawn to parrot tulips with their weird, warped petals. With their brush-stroke-like markings in a contrasting palette, they simply fascinate me, as do the chic French tulips, always about 6in/15cm taller than their Low Countries neighbours. Simply plonked in a vase, they develop and unfurl, the flowers opening as they settle into a warm room and their stems moving in the slowest of slow-motion dances, as they aim their phototrophic faces towards the available light.

But the winner for me every March has to be the golden glowing daffs – the fabulously varied narcissus seen in happy abundance throughout New Covent Garden Market. I always make a beeline for Pratleys, who specialize in British-grown flowers. Stacked a metre high, short squat boxes almost bursting at the seams are filled to the

One of the unending joys of the Flower Market is its people. My relationships with these characters, as varied as the flowers they sell, have been established over years of early-morning meets. Bumping into them is as pleasurable as the random unexpected discovery one chilly morn of a fabulous and unexpected bundle of blooms normally seen much later in the year, like these gloriously fragrant tuberoses from Iran – as fresh as fresh can be, with a heavenly, heady scent that is irresistible.

very lid with bunch after bunch of budded beauty. Some growers choose to pick their narcissus crops when the flowers are opening, so you can see exactly what you are purchasing, while others send in anonymous rubber-banded bunches of buds, each flower concealed by a brown tissue paper-like sheath, which will slowly rustle and shrug itself off as, once in water, the flowers awaken. The boxes are labelled with evocative names such as 'Golden Ducat', 'Ice Follies', 'King Alfred', 'Pheasant Eye' and 'Tête-à-Tête'.

Outside the Market at the foliage stands there are also signs of spring, with vast bundles of silken pussy willows and armfuls of shiny-leaved camellias. The latter arrive into Market stitched into hessian bundles, almost too heavy to lift, and looking more like a body being dumped overboard than a wondrous collection of stems, each dotted with fat juicy buds nestling amongst the glossy greenery. Related to the tea bush, camellias supplied to the Flower Market are grown in Cornwall. I like to rootle among the bundles as they are unpacked, cherry-picking the stems with the biggest bulging buds to take back to the workroom, where we stand them in buckets of water in a cool, quiet corner and let nature take its time, treating us to a fabulous flowering in a week or so. Like crinoline ladies, the multi-petalled flowerheads work beautifully, arranged just as they are in a vase or as a foil to other stems of spring blooms, or even simply floated in a shallow bowl of water. Slowly, the colour returns to our days.

As a child, one of my clearest memories is of being shown by my paternal grandmother how a snapdragon flower got its name. And, to be honest, I'd still choose the fun familiarity of that naïve nomenclature over the impossible-to-spell antirrhinum (which just took me six attempts and then a swift Google to get right). These flowers are now available to us for much of the year and always appear fulsome and colourful, despite how randomly they may appear in March. While they wouldn't be my bloom of choice for spring decorations, if we want to create an out-of-season summer arrangement, they are a boon. And when they are in season, they are a joy, though still just as tricky to spell!

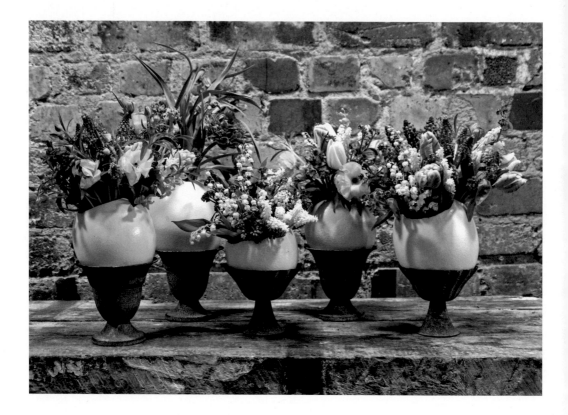

Easter egg vases

I much prefer it when Easter falls while the last of the British spring flowers are still around and the bounty of the early summer blooms has just begun to appear at the Flower Market. Inspired by the egg-cup arrangements I created as a child using odds and ends picked from my parents' modest Warwickshire garden, this decoration features parrot tulips, white and blue muscari, butterfly ranunculus, lily of the valley, forget-me-nots, French tulips, hyacinths, fritillarias and *Iris reticulata*.

I like to create a little row of eggs, each with its informal arrangements of spring flowers.

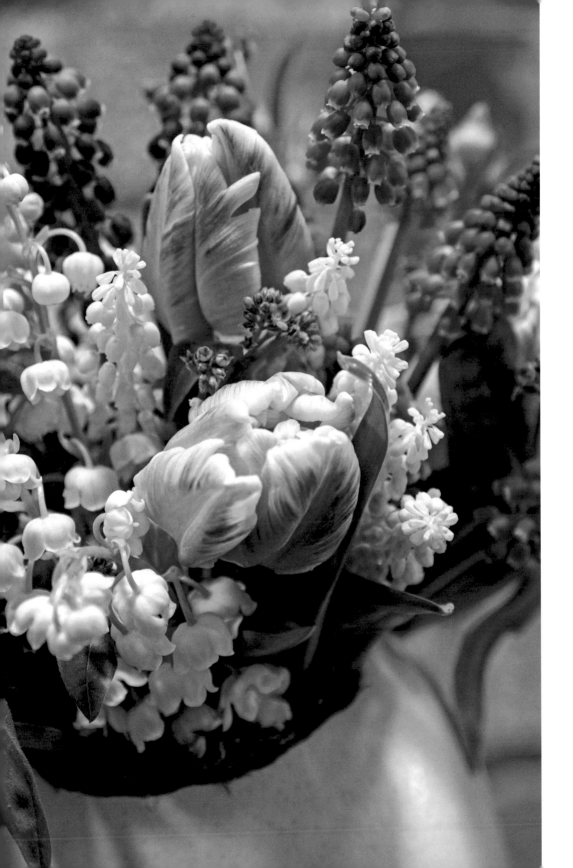

1

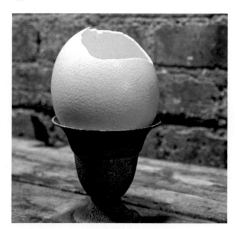

I love the simple form of eggs, and be they chicken, duck, goose or, as here, ostrich, they make wonderful vases if carefully emptied, rinsed and then placed in an egg-cup-style container.

2

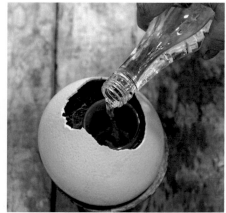

The shells can become porous, so if I need them to last a few days, I use a small jar or shot glass as a liner, securing it with some moss or wadding before half-filling it with water.

4

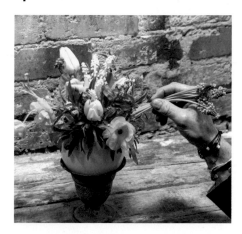

Adding the flowers singly, or in the case of slim stems of muscari a few at a time, enables you to create an informal but not sparse style of decoration.

3

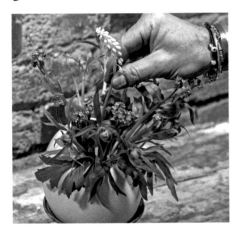

When arranging smaller decorations flowering foliage will provide a double whammy. Here stems of forget-me-not are perfect as a base and support the slender stems of spring flowers.

5

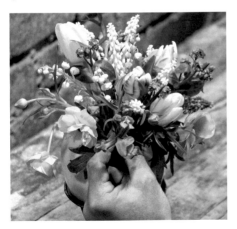

As with most styles of flower arranging, save the best till last. Add your precious star performers at the end, ensuring they are undamaged by other additions and remain the most focal flowers.

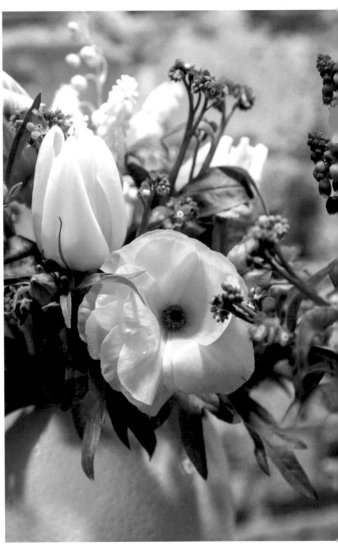

To make sure your spring flowers retain their delightful freshness for as long as possible, and because they tend to be very thirsty, remember to keep their little vases well topped up.

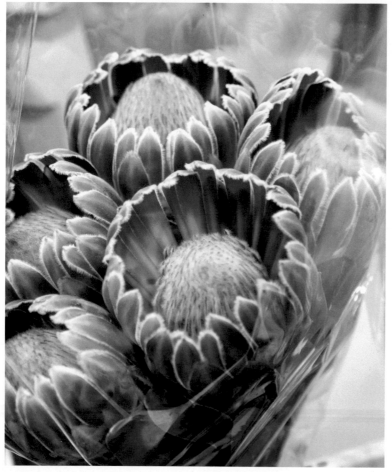

On a grey spring morning in the Market, buckets of chunky Cloni ranunculus (ABOVE) will catch my eye along with wraps of regal King Protea (LEFT), imported from South Africa. But the award for 'most colourful' goes to rows of soulless yet striking Phalaenopsis *orchids (OPPOSITE), risking the potential death-knell of a frosty blast, caught between market hall and van as a chatty buyer lingers in a doorway.*

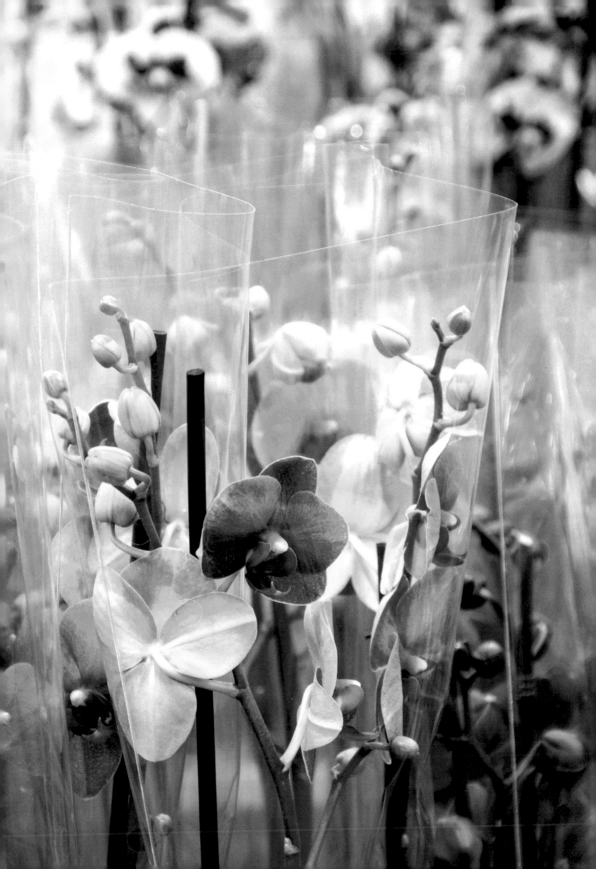

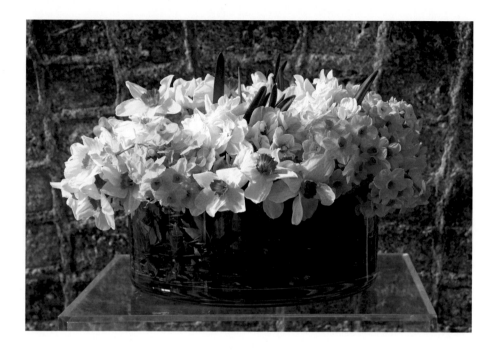

Mixed daffodils

Wherever you are in the UK during March, you won't have far
to search if in need of a bunch or two of these British-grown
flowers. Flower shops and farmers' markets, as well as farm shops
and greengrocers, will have them in open boxes leaning up next
to their doors, and the prices will generally be so low that you
wonder what the poor soul gets who grew them. So be reckless
and buy yourself a goodly armful. Once arranged, they will last
for ages and be as cheering as a bright sunny day. No specialist
skills are needed to enjoy them. Just cut half an inch or so from
the ends of their stems and pop them into a vase, jug or jam jar,
two-thirds filled with water, and then wait for the sun to shine!

1

Assemble your plant material and chosen vase, along with a square of 2in/5cm chicken wire approximately twice the size of the opening of your container (so for a 10in/25cm bowl use a 20in/50cm square). Roll its corners towards the centre to form a mounded shape and nestle into the bowl.

2

Use some stems of trailing ivy or some relatively dense foliage to swirl between the edge of your container and your chicken-wire dome to conceal the wire. If your container is opaque you don't even need to bother with this step. Fill the vase two-thirds full of water.

3

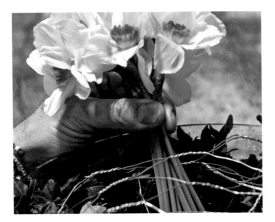

Edit out some of the leaves, arranging a bunch of flower heads into a dome-shape. Trim the stems so the flowers sit just above the vase rim. Then feed the stems between the network of chicken wire, nestling them into the bowl.

4

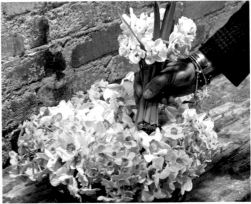

Working with one variety of narcissus at a time continue as before, tweaking their heads as you add each bunch to ensure they all have their starring moment. When finished, top up with water and enjoy them.

Fritillaries

In the next-door-but-one house to my childhood home lived a pair of
spinsters. Life-long friends and former teachers (one an Oxford scholar,
the other a Cambridge graduate, one loving red and the other blue)
Miss Free and Miss Wheeler, collectively known as the Free-Wheelers,
were surrogate grandparents to me. For many formative years, I would
call on them on my way home from school to test my homework
spellings, to chat about my day or I would read to them – A.A. Milne
was a particular favourite. From them I learned about Flanders and
Swann, how to use an encyclopedia, the joys of Wimbledon fortnight
and the music of Gilbert and Sullivan. I also gained a life-long love of
gardening and growing, and plants, as both were avid gardeners. They
had a greenhouse in which I spent many happy hours learning to take
cuttings and sow seeds, prick out seedlings and pot up dahlias in the
early spring and box down their gnarled tubers in the autumn, in trays
of sharp sand and wrapped in copies of *The Daily Telegraph*.

In addition to jewel-bright dahlias, their garden was abundantly
flower-filled during the spring months, with varieties that were
unknown to me and deeply exotic. I will never forget the first time
I saw Crown Imperial fritillaries, which thrust themselves proudly
skywards in pots on their patio. Ever since I have had a lifelong love
of this extraordinary and exotic flower. And whenever they appear in
New Covent Garden Market, certain wholesalers know to save me
some. Many people dislike their foxy fragrance but to me it's mysterious
and earthy aroma is one more reason to be totally captivated by them.
Here a simple vase makes the ideal home for armfuls of them.

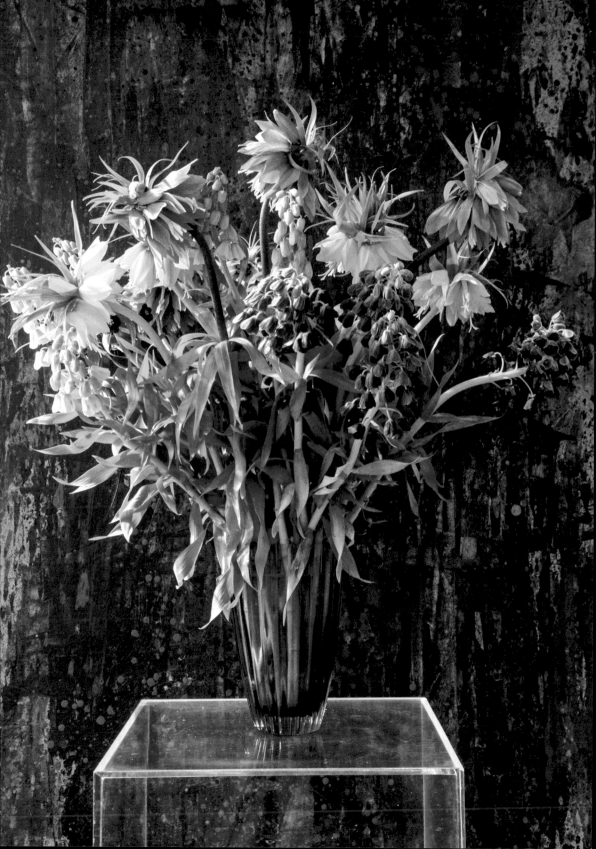

April

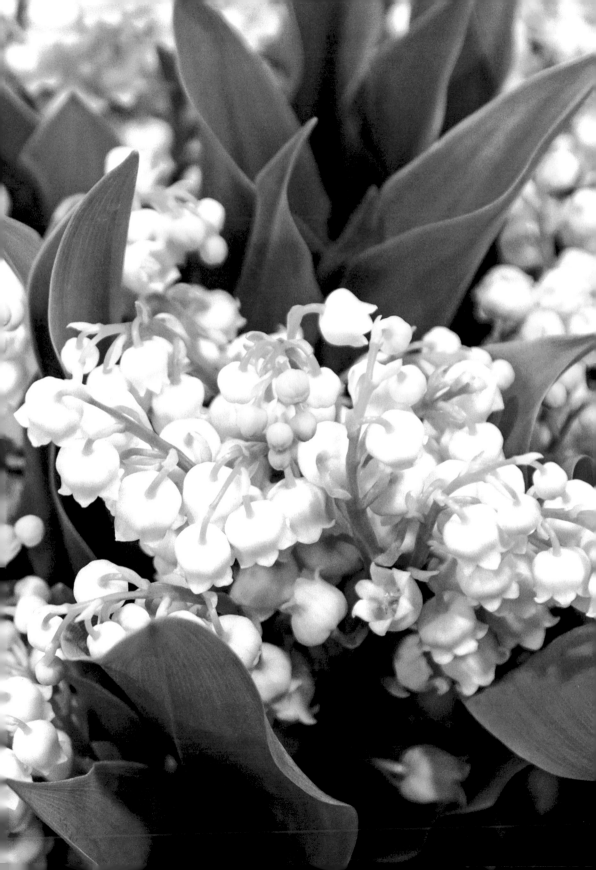

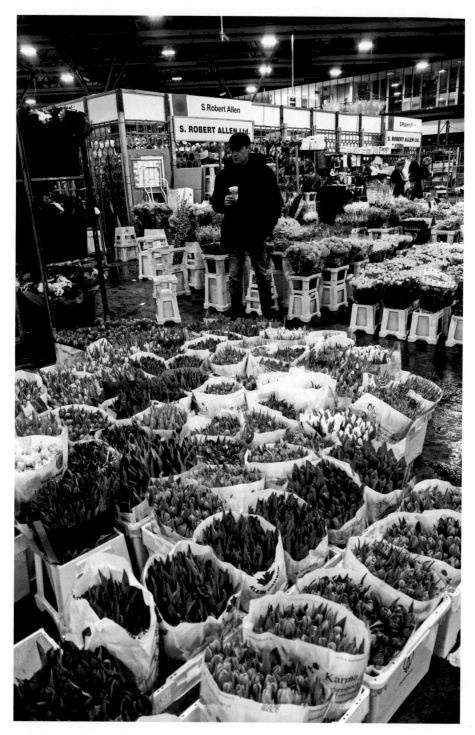

I THINK MOST PEOPLE would assume that in April the Flower Market is an explosion of eggy yellow, with buckets of bright, bold daffodils and narcissus blooming beneath wands of pussy willow and wiggling branches of catkins, gutsy bundles of forsythia and tall boughs of blossom, with swathes of hyacinths and tulips for scent and colour respectively. In fact in April the floor of the Flower Market becomes a tapestry of tulips, in a vast array of varieties, from torn-edge-petalled parrots to the exotics that appear to have had their flowers dipped in sugar crystals and desiccated coconut, as well as the more traditional egg-shaped blooms and buds.

At this time the Market becomes a doubly delectable place to be and to buy. As demand for flowers increases with lighter days, better weather and the Easter holidays, the suppliers and wholesalers from Holland and across the world begin cutting and sending to auction a much more varied and exciting assortment of foliage, plants and flowers. And the warmer weather often accelerates early British foliage and flower crops. It only takes a few warm days for bundles of vivid green euphorbias, ghostly grey artichoke leaves and plump bud-laden branches of blossom to start lining up in tubs and buckets, along with tall stems of cornus and ornamental currant, shiny camellia and bright, burgeoning horse chestnut and beech stems.

Some of the British growers show off with their first flush of home-grown sweet peas, and we florists greet them with as much

The British-grown tulips tend to be packaged in paper-wrapped bundles and tucked into boxes while those from the Netherlands are transported in shallow tubs, perfectly supporting these weighty and wonderful flowers which kick-started the Dutch flower-growing mania back in the 1600s.

63

excitement as a sommelier welcoming the arrival of Beaujolais
nouveau, or a chef the first asparagus or Jersey Royal potatoes.
And from Holland bunches of paeonies and lilac start to appear,
along with foamy *Alchemilla mollis* and pristine hosta leaves.

While for a week or so this bounty swells the flower stands,
sitting alongside the homegrown talent, it soon begins to replace
the daffodils and the forsythia, and gradually the flamboyant
Italian and Dutch Cloni ranunculus start to diminish, in both size
and abundance, together with other early spring treats.

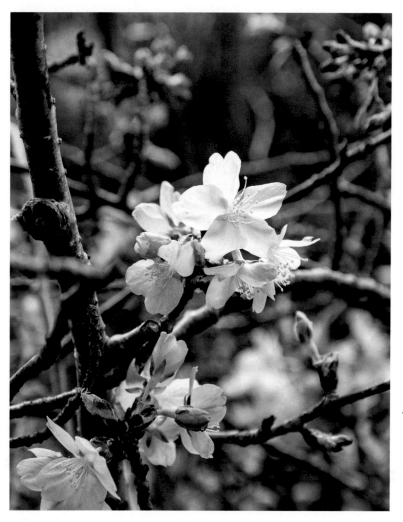

*Branches of blossom always
lend scale and substance
to spring decorations,
and at the Market the
foliage stands specialize
in cheating the weather
through March and April,
endeavouring to supply us
demanding florists with
bloom-bejewelled boughs
in heights from 3ft/1m to
10ft/3m.*

A ROYAL EVENT

When the Prince of Wales married the Duchess of Cornwall in 2005, the wedding reception was due to take place at Windsor Castle on 8th April. I was asked to create floral decorations to greet the guests as they arrived, as well as those in the Grand Reception Room and the Grand Staircase that ascends to it. A magnificent and vast Malachite Urn holds court in the window at the far end of the Grand Reception Room, crying out to be filled with boughs and branches of every colour and variety of blossoming tree and shrub from the royal estate. So I was lucky enough to be invited one late March morning to plunder the verdant glades and copses of Windsor Great Park and the Savill Garden. It felt so wrong, but also so, so right, to be able to point to the most magnificent and stunning stems and request that they be felled for my delight and for 'The Urn'. With our trailers filled, we headed back to the Home Farm to cut and condition, hoping that the buds would begin to open, and the colours reveal themselves, in time.

Creating the right arrangement against the backdrop of the Grand Staircase proved a challenge. An arsenal of military paraphernalia adorns the honey-hued walls and, flanked by bronze cannons and pyramids of cannon balls, ancestors of our Queen, carved and cast in bronze and stone, gaze down on stacks of drums beneath, which rise up like giant, tiered wedding cakes. My decoration needed to be big enough to be noticed, detailed enough to hold people's interest for a few lingering moments and bold enough to give a wonderfully warm, floral welcome to this special wedding celebration. And I needed a pair of them to flank the top of the stairs and guide guests to the Waterloo Chamber ahead. Right from the start, I had wanted the Prince of Wales's wedding to feature an array of emblematic daffodils. As well as being the Welsh national flower, the daffodil works best used in abundance. But most narcissus and daffodils are coming to an end by April, so obtaining the volume and variety required to do justice to the occasion would be a challenge. The cry went out across the land for all and every grower to collect and cosset every last blooming stem.

We managed to obtain the many thousands of stems required
and create the conditions to arrest further flowering. All was set.
We had made it! And then the unthinkable happened...the Pope,
His Holiness John Paul II, died. And the Prince of Wales had to
postpone his wedding by 24 hours. Though another day might
not seem much, flowers such as daffodils and narcissus, once they
are fully flowering, have a finite window of being wonderful.
And the clock had already been ticking...

A day after we had planned to be doing so, vans, flowers and
florists arrived at Windsor, where everything else was slightly
discombobulated by the delay, too. What should have happened
on Thursday was now to take place on Friday. So Team Lycett
set to and we created our decorations, with the help of a scaffold
tower, as the Malachite Urn was filled with a 25ft-/8m-tall feast
of spring gorgeousness.

At the top of the Grand Staircase, we positioned our pair
of chicken wire and timber frames and began to work with our
precious gold – the daffodils and the narcissus. Normally I avoid
flower foam for soft spring stems and usually arrange them in
water. Just because these decorations were each 12ft/3.5m tall
didn't mean we had to work any differently, so the bunches
were arranged in a multitude of plastic cones, each with a small
reservoir of water to keep the flowers fresh. Throughout the day
the pair of columns of wonderfully bright blooms were created,
with beneath them a garden-inspired assortment of mosses with
hellebores, fritillaries and muscari in bloom. The finishing
flourish to each was a topiary Prince of Wales's feathers, created
from chicken wire and boxwood, clipped to resemble the real
thing. (I am told these provided a moment of light relief when
spotted by a nervous bride-to-be as her future mother-in-law gave
her a tour of the floral decorations the night before the wedding).

Mrs Parker Bowles-that-was wasn't the only one to have spent
an anxious night before the Big Day. As I departed that Friday
night, the historic heating system of Windsor Castle was being
fired up at full steam to ensure all would be cosy and comfortable

Across the year, flowers at the Market are usually a good couple of months ahead of those in our gardens, extending the window of availability of seasonal treats such as lilac, paeonies, dahlias and narcissus. Narcissus and daffodils, like those here, started arriving in very early spring and by April they are scarce. Offering flowers at Market a few months ahead gives them added kudos and increases the price they can command.

for the guests the following day – great for them but far from ideal
for our fragile flowers!

So, a much-less-confident-than-normal me returned with
my brilliant team early on Saturday to give our arrangements
the once-over before the security cordon tightened around the
Castle for the arrival of over 800 guests, including umpteen
crowned Heads of State. The warmth of the Windsor boilers had,
overnight, encouraged some shy camellia and magnolia flowers to
make an appearance in the Malachite Urn, but would the fragile
daffodils have succumbed? I remember to this day the relief
we all felt when, turning the corner from St George's Hall and
passing through the vestibule, we saw ahead of us a pair of perfect
columns, gleaming and bright like golden pillars, with each and
every single flower looking fabulous and fresh, pert and perfect!

Massed hyacinths

The Dutch truly have mastered the art of growing spring bulbs as indeed they should, having been at it since the 1600s. Their sandy soils, reclaimed from the North Sea, are perfect for bulbs of all types and hyacinths are no exception, thriving in the well-drained fields of the Netherlands. For me hyacinths can become a bit much, as while they look and smell fabulous in the budding and semi-opening stages, once the flowers tip over into full-blown, to my mind (and nose) they lose their charm and the initial scent becomes cloying and overpowering. However, the buds have an architectural quality about them which is hard to resist. As a result, they rarely hang around long at the Market before being snapped up, so the scent is barely discernible as I walk past tubs packed with squat wraps of white paper, each containing 25 stems. These weighty bundles will take anything from two to five days in our cool workroom before they begin to show enough colour to use in displays while still smelling sweet enough for me to consider including them in my designs.

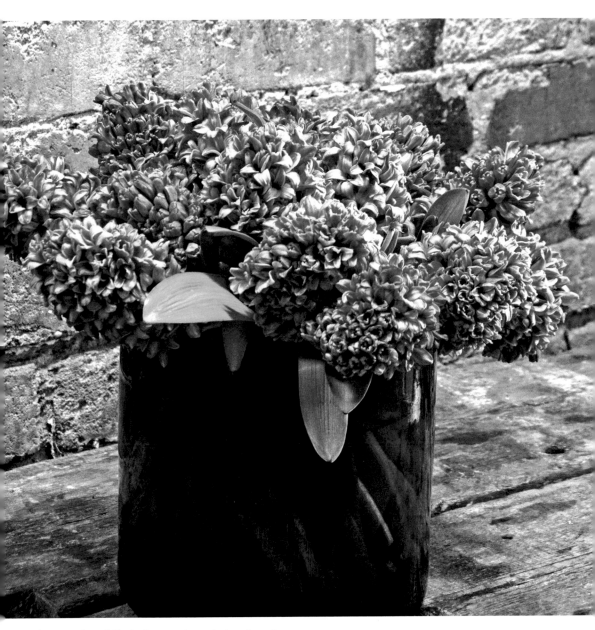

There is nothing difficult about creating a glorious decoration
when the flowers work busily on your behalf, as with these deep
blue hyacinths, which only needed to be removed from their
bunches with a few of their leaves edited out. I cut the stems to a
length (OPPOSITE) that allowed the flower heads to sit at the rim
of the vase and, using both hands, gathered them together and
popped the whole lot into the vase in one go (ABOVE).

69

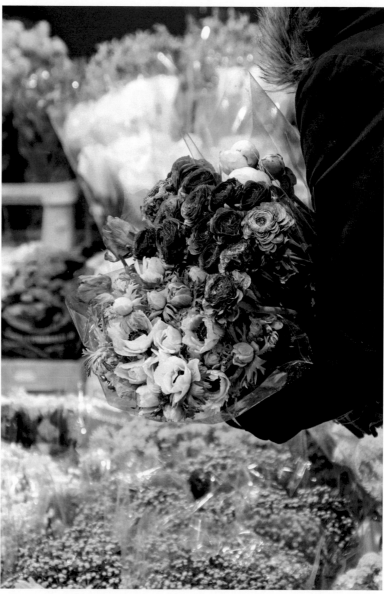

Buyers, their arms filled with bulky bunches of anemones and
ranunculus are a common sight in April (ABOVE), as everyone
is wooed by such seasonal treats, and still feeling the spring vibe.
Towards the end of the month when the first of what many would
consider summer flowers begin appearing, the clever foliage suppliers
will still be tempting us with tall boughs of blossom (OPPOSITE),
kept cool or cosseted to encourage its opening, depending upon what
Dame Nature is up to outside.

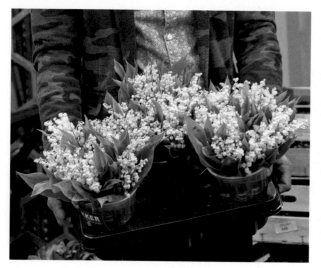

Lily of the valley

In late April some of the most fragrant of all the flowers appear in the Flower Market, and frequently it's my nose that leads me to these precious goodies, as pots of sweet peas and bunches of British lilac send scented signals to attract attention. But in the last week of April, the British-grown lily of the valley begins to arrive. I am sure I have already claimed one flower or another as my all-time 'fave', but the British lily of the valley would be one of my chosen Desert Island flowers. Fortunate as we are to be able to obtain the Dutch-grown version all the year round (and at a very reasonable price considering how tricky it is to produce flowering stems all across the year), there is no doubt that British-grown ones are the *most* magical of flowers, their verdant wiry stems suspended with bells seemingly carved from ivory, and drenched with the freshest and most rounded of fragrances.

With pot-grown lily of the valley (ABOVE), trim the roots while retaining the band which holds the rootball together. Using a vase into which the stems fit snugly, place the flowers in an upright manner, as if growing (OPPOSITE), and top up with water.

While we gladly and gratefully make do using the rather anaemic all-the-year-round stems, once the home-grown bunches arrive, it's wonderful to celebrate them in all their exquisite glory, in jewel-like bridal bouquets or as simple 'plonks', but whatever and wherever, they are always, and in all ways, an utter delight.

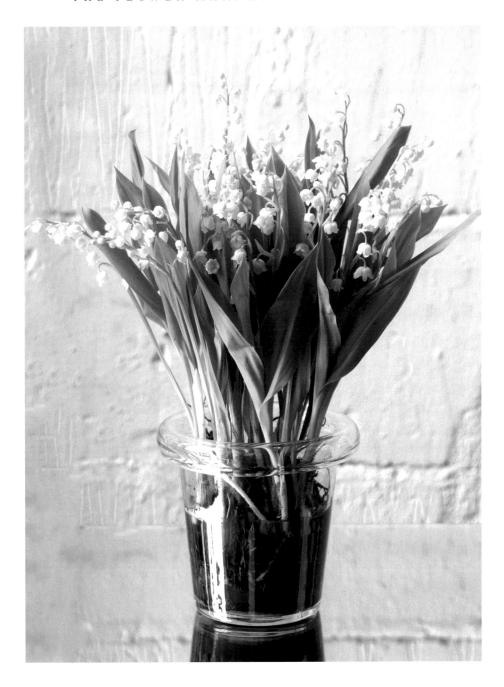

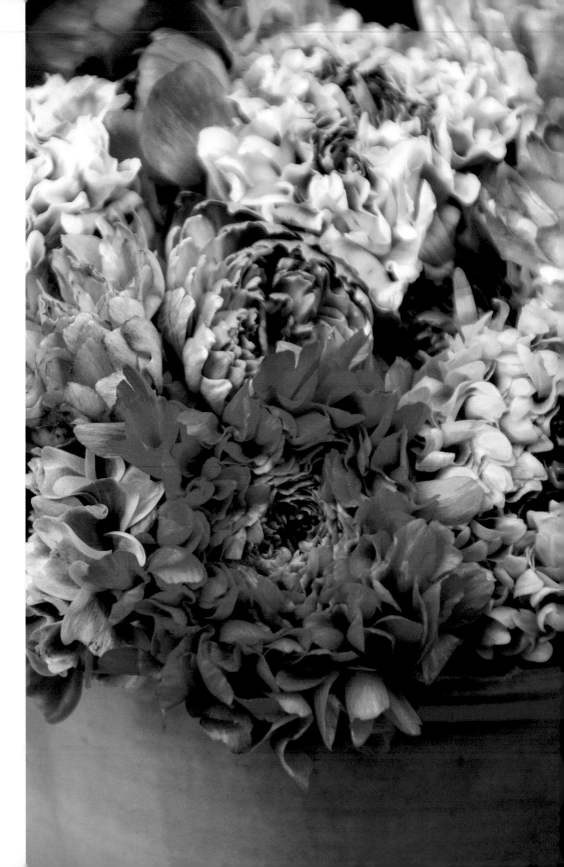

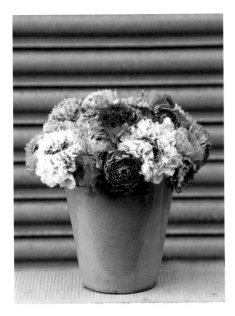
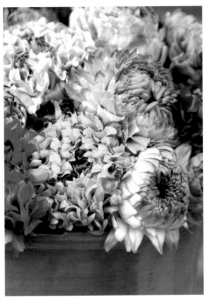

Ranunculus

As a child, I remember a neighbour of my parents had a tall ceramic vase in her hallway, into which were arranged the most spectacular assortment of tissue-paper-like flowers. In a five-year-old's memory, they were enormous and multilayered in a really riotous assortment of colours. I thought they were so much more glamorous than the exhausted-looking Christmas cactus in our hallway which struggled to do more than reward my mum's patience with half-a-dozen livid pink flowers. Each time I see a wrap of the more spectacular Cloni ranunculus, I'm reminded of those fantastical flowers, particularly when the so-called 'Fancies' appear. Most flowers sold in the Market, and certainly those from Dutch growers, are prepared and packaged in single, self-coloured wraps, bunches, bundles and buckets. So a carnival-crazy colour combination is bound to catch the eye, especially when it's as show-stopping a selection as these. Each flower is individual, with pinking-shear-edged petals, some striped in green and white, splashed with cerise and scribbled in yellow and pink. Always an expensive purchase, they need almost no arranging at all, allowing their natural, and very unnatural, beauty to simply shine.

Ranunculus, especially Cloni ranunculus, lose their impact the moment their cellophane wrapping is removed and the magnificent concentration of multi-petalled flowers broken. So I mostly arrange them in a style that mimics their initial impact. Here, I just removed the lower leaves and, using my hands, gathered the heads together to form a pleasing dome, securing the stems with a rubber band before trimming them and dropping them into a water-filled glazed pot.

75

May

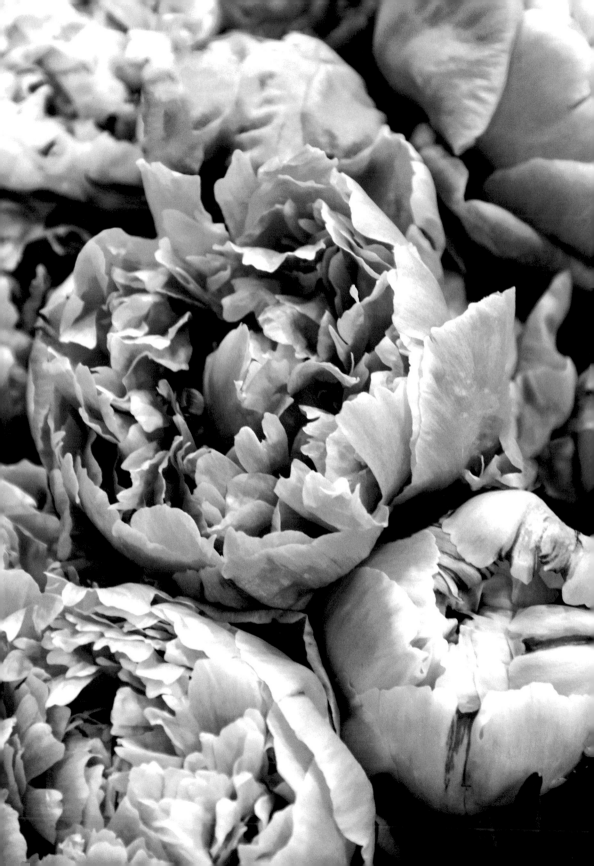

THE BUILDING AND REDEVELOPMENT WORK all around New Covent Garden Market continues apace and I am amazed at the speed with which each monolithic structure rises ever higher. Poured concrete seems to be the building material of choice and vast silos of the stuff are being stockpiled on the site of what was Market Towers, where I used to bank my wage cheque each week when working for the late Robert Day. His iconic '80s' flower shop based in the Pimlico Road had a workroom beneath the railway arches in nearby Miles Street.

Whenever I meet people who have yet to visit the Market I always urge them to wait until May to do so. It's the time when each and every stand is at its busiest, and when the building is groaning with colour and greenery that bursts forth at every entry and exit. Stands such as Pratleys, which specialize in British-grown produce, have boxes piled high with all my favourites, including stacks of fragrant Doris 'pinks' together with all her tonal sisters and brothers, each fabulously named as if by a horticultural Charles Dickens: 'Widecombe Fair', 'Mrs Sinkins' and 'Haytor' among them. Chunky bundles of delphiniums in every shade of blue, spires of vivid lupins dazzling in buckets and boxes of immaculate alliums, each bunch tightly packed in serried rows, are piled next to foamy bunches of *Alchemilla mollis*. On the periphery of the Market, the foliage stands are fuller and busier than at any other time of the year, with the exception of December and its dreaded Christmas trees. Bundles of fragrant lilac slowly wilt in the shade, desperate to be bought and plunged into deep water in a shady workroom. Lavender in huge sheaves gives off its heady fragrance and draws bees from heaven-knows where. I always want to buy it all!

By May, the Flower Market is a riot of colour, with everyone vying for space to showcase the start of the summer flowers along with the last of the spring blooms. Ranunculus and tulips rub shoulders with paeonies and lilies, lilac and larkspur, forsythia and forget-me-nots. Some stands display their wares by colour, others simply by variety, but the entire effect is a joyous cacophony of floral fabulousness.

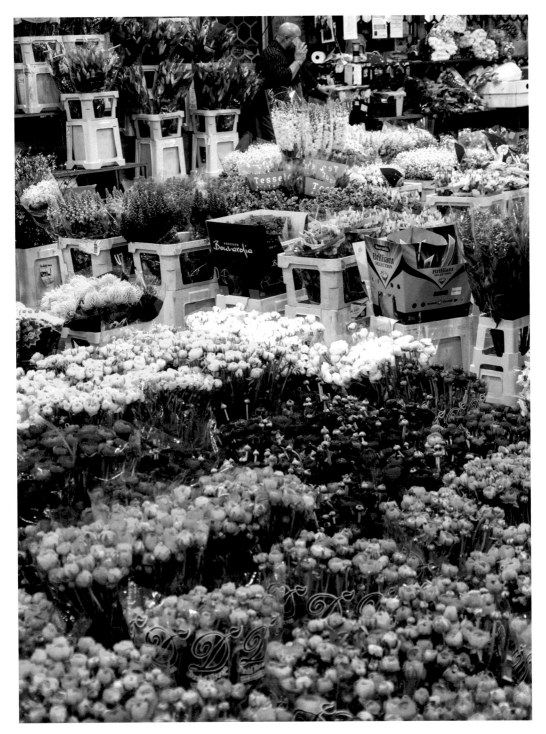

Spring flower medley

In May, we florists get the best of both worlds or rather seasons, as there are still plenty of spring flowers to be enjoyed and the early summer flowers start to appear. Often there is quite a difference in scale among these mixed seasonal flowers, with some, like dainty aquilegia and fragile forget-me-nots, being overshadowed by more visually boisterous stems of paeonies and parrot tulips. A swift, simple way to enjoy a really wonderful mixture of flower forms and colours is to arrange them in a curated collection of containers. In this case, different sizes and shapes of vintage bottles become the perfect receptacles for some precious stems, but assorted wine glasses or tumblers, or even tea cups or mugs, would also work just as well.

When arranging a mélange of flowers, I find that single varieties, like the parrot tulips, aquilegia and forget-me-nots here, work best arranged in individual vases, creating a cohesive design once assembled, perhaps placed together on a slate tile or old shallow tin tray.

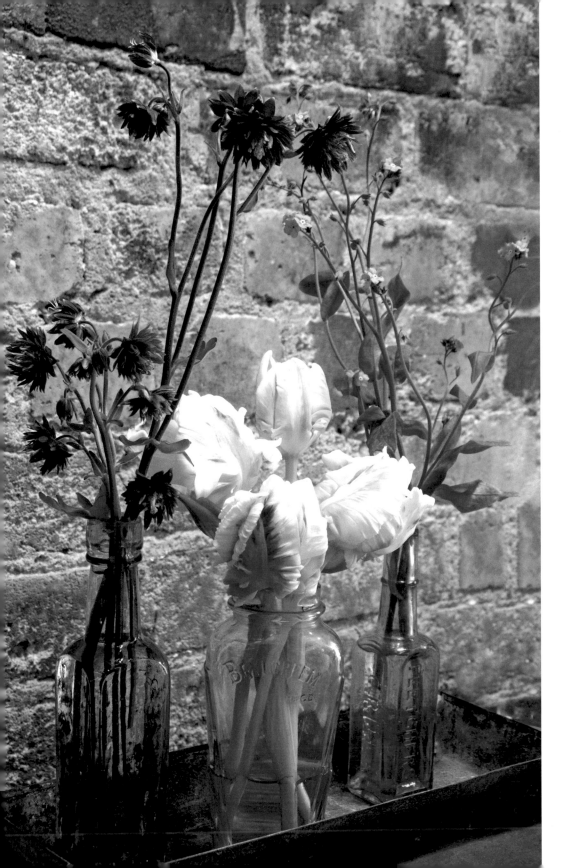

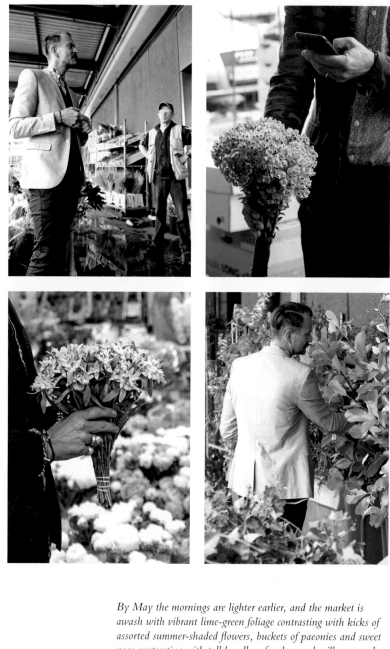

By May the mornings are lighter earlier, and the market is
awash with vibrant lime-green foliage contrasting with kicks of
assorted summer-shaded flowers, buckets of paeonies and sweet
peas contrasting with tall bundles of sorbus and milky-sapped
euphorbia (TOP RIGHT). Among this seasonal splendour there
is the serendipity of occasionally spotting a random bunch
of edelweiss (ABOVE LEFT) or a few bunches of magnificent
proteas (RIGHT).

Garden pinks

The delicate frills of these flowers (their name comes from the 'pinked' style petal edges) remind me that as a seven-year-old child, staying over Easter with indulgent friends of my parents, I was allowed to spend many happy hours ploughing through packs of red paper serviettes creating vases filled with flowers, and writing off a perfectly good pair of scissors in the process! I think of that Easter each time I work with carnations and pinks.

Even as a child, bunches of mixed 'pinks' enchanted me and the thrill I get now when spotting the first boxes of these simple yet scented treats in the Flower Market is possibly even greater! They, along with narcissus and sweet peas, 'bloom' chrysanthemums and belladonna lilies, are one of the flowers that British growers still send to market in small, yet vastly superior, quantities to their Dutch counterparts. I buy pinks by the box, sometimes mixed but often in single varieties and always banded in bunches of ten stems, laid in a series of rows held in place with spiteful tin braces stabbed through the box sides. They must be the fiddliest of flowers to pick and pack, but after such careful packaging they are still inexpensive enough to make them affordable by the handful from your local flower shop, stall, or farmers' market. So when next you spot them, often sold propped up within their market boxes, treat yourself to the scent and sight of the good old days and buy a few fistfuls of fragrance. I like to create simple arrangements of mixed pinks, sometimes enhanced with sprigs of foamy green *Alchemilla mollis*.

1

*Assemble your plant material and chosen vase. Fill the vase
two-thirds full of water. Remove any rubber bands or ties from
all bunches and take off lower leaves from the stems.*

2

Use your hand to support the flower heads as you form a loose and soft dome shape. Avoid crossing the stems. Once happy with the shape that the massed flowers form, secure the stems with a rubber band a few inches below the flowers to hold them in place and then trim the stem ends to the desired length.

3

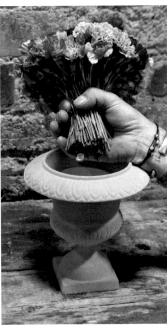

Place the entire handful of flowers in your container – tweak any errant blooms into line and top up with water. Enjoy!

June

IT'S ALMOST IMPOSSIBLE to squeeze amongst the rows of flower-filled buckets on almost all the flower stands at this time of the year, as every bloom feels fulsome and fabulous, and the tapestry of colours a magical sight. Even when I'm tired on a cold wet June morning, my heart still lifts at the sight of a table laden with bundles of British lavender, often gathered in Kent, or of rows of white card boxes with their lids off and their tissue veils lifted to reveal bunches of pristine, British-grown sweet peas in a palette of macaroon shades, held in place by newspaper bands sewn into each box with twine. The packaging and transport of such precious peas is an art form in itself.

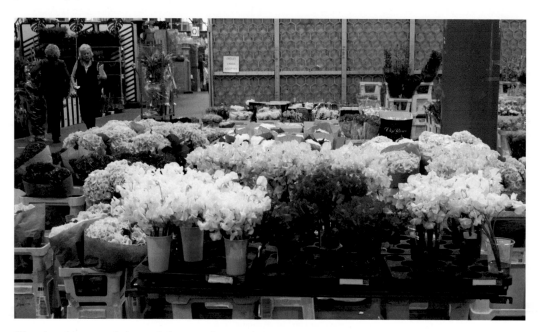

There is nothing more glorious and glamorous than wandering past an abundant assortment of sweet peas giving off wonderful wafts of summer.

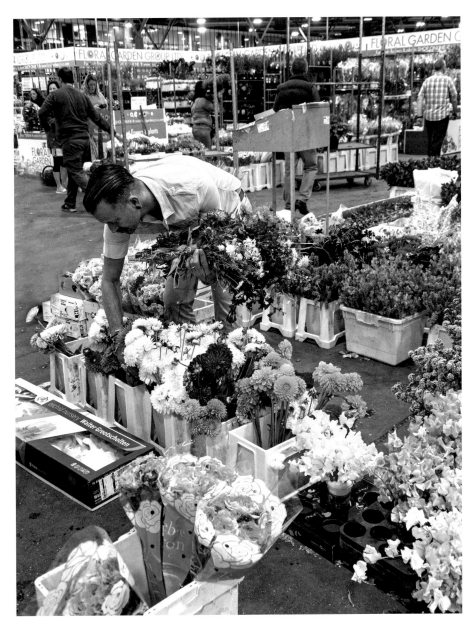

*Arms filled with every type and colour of summer flower
is what June visits to the Market are all about, and even
if I have a really prescribed list of what I'm to buy, it's
almost impossible to resist the lure of delicious dahlias
fresh from Hampshire, aquilegia and forget-me-nots
from Lincolnshire and just a few Dutch-grown garden
roses to add yet more fragrance.*

In May and June, sweet peas and paeonies arm-wrestle one
another for pole position in the Flower Market and during June I
think the paeonies win! The paeonies too, have different personas,
and all tend to begin their metamorphic progression from bud to
bloom in buckets, looking far from fabulous. I remain in awe of the
fact that a drumstick-like paeony bud – a conker-sized capsule atop
a sturdy stem – will, within a few days, swell, open and unfurl into
a frothy feast of tissue-paper petals with the most ethereal, gone-
in-two-inhalations fragrance. Once they begin to open, paeonies
have a few more tricks up their summer sleeves: some of the fattest
buds open to reveal the fewest petals, surrounding a silken tassel
of stamens and a star-shaped corolla, and others go from looking
like hard-boiled eggs to become a magical, multi-layered meringue
of petals. The sensuous-looking though sinister-sounding 'Dr
Fleming' develops from beetroot-coloured buds into diva-like dark
and dreamy flowers, the petals often parting to allow a glimpse of
strikingly vivid yellow stamens. But the most deceptive of all must
be 'Coral Charm', whose cherry-coloured buds slowly unfurl to a
soft peachy-coral, before adopting a parchment palette as they fling
themselves wide open. I often spy a bride-to-be with her entourage
of amateur arrangers exploring options at the Market, with much
swatch-matching to flowers and buds, and I cannot help wondering
if anyone has matched their bold bridesmaid's dress to a 'Coral
Charm' bud only to awake one morning to discover a more Miss
Havisham-style flower seems to have arrived instead!

The other major excitement during June is the sudden
swelling of the Flower Market's repertoire thanks to the home-
grown gang arriving on the scene. For British foliage and flower
growers this is a bumper month. If we have specific projects for
which a smörgåsbord of colourful and seasonally inspired flowers
is required, I'm tempted to arrive at the Market at first light in
time to snaffle from G.B. Foliage some of the fantastic mixed
buckets filled with treasures as varied and valuable as a country
garden. While the Dutch and the larger British growers send
everything to the Flower Market as standardized stems, many of

the smaller British flower-growers will pick and bunch as they
walk their rows of cutting flowers, gathered from plots as varied
as ex-council nurseries in London, family farms in Hampshire
and picturesque flower fields in Oxfordshire. While the growers
mostly sell at local farmers' markets and to visiting florists, with
the summer glut a wonderfully symbiotic system comes into play.
Small growers, inundated with *Ammi* and *Alchemilla mollis* and
cornflowers and cosmos, find it worth the early drive to Vauxhall
to swiftly shift some buckets at a premium price, as the demand
in London for such short-lived summer treats skyrockets (thanks
to social media), further driving up the value of these often
garden-gathered treats. It's from these pick-and-mix assortments
that I'm able to acquire slender stems of astilbe and astrantia, fuzzy
bunches of summer-sky-blue love-in-a-mist (*Nigella*), arching
branches of elegant lilac, and bundles of lanky scabious. Mixed
sheaves of sticky-stemmed marigolds add a pop of vibrant colour
among this more tonal team, with clusters of heavy-headed
and fragile garden roses, freshly picked on the Hampshire hills,
completing my summer miscellany.

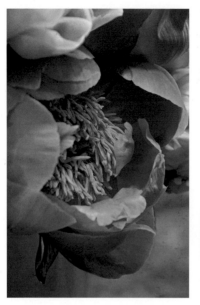
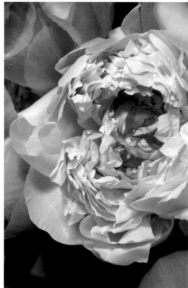

Paeonies in a pot

Of all the flowers in all the world, the one that clients request and
desire more than any other is the paeony. Pink, white, coral or
burgundy, short-stemmed or long, they would like to have them
all the year round. But, for me, one of the reasons that they are so
deeply desirable is their very brief window of appearance, usually the
halcyon months of May and June, associated as they are with the first
sunny weather, lazy bank holidays and friends' weddings and parties.
Discounting the errant bunches of surprisingly special paeonies
that suddenly appear from New Zealand and Israel over winter
(particularly around Christmas), they are one of the few flowers that
appear to have defeated those clever Dutch growers. Tulips are now
available and excellent every month (though why anyone wants them
from June to December baffles me) and magnificent garden roses
appear every day of the year. So I suspect that somewhere in a boffin's
basement or a plantsman's potting shed something is happening to give
us dreamy and deliciously decadent paeonies all year long. Meanwhile,
I just enjoy their short-lived lovely lives.

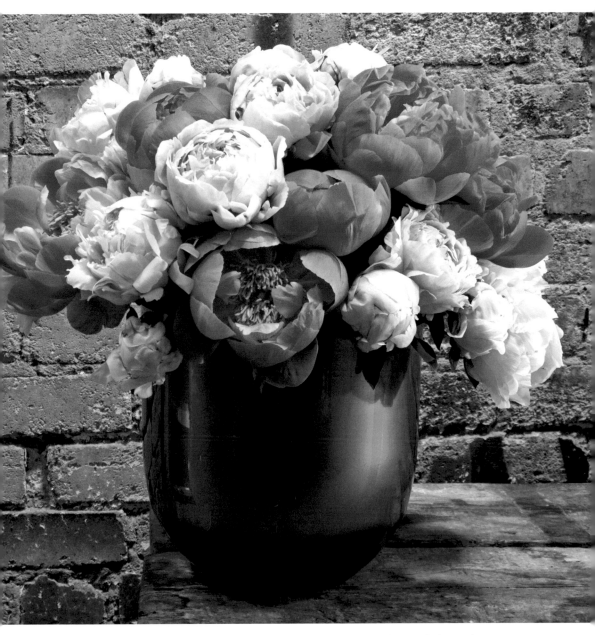

The magnificent and multi-petalled paeony flowers emerge from marble-sized buds, so this style of decoration will only work when the flowers are well developed. Whilst not long-lasting it is certainly a show-stopper and demonstrates exactly the stage at which we would want our paeony flowers to be for the event work which is at the core of what we do. It can take a week for the tightest of buds to bloom, so do bear this in mind when planning any decorations for a special event. If not, simply buy a bunch or two and enjoy the gestation period of these most stunning of summer flowers.

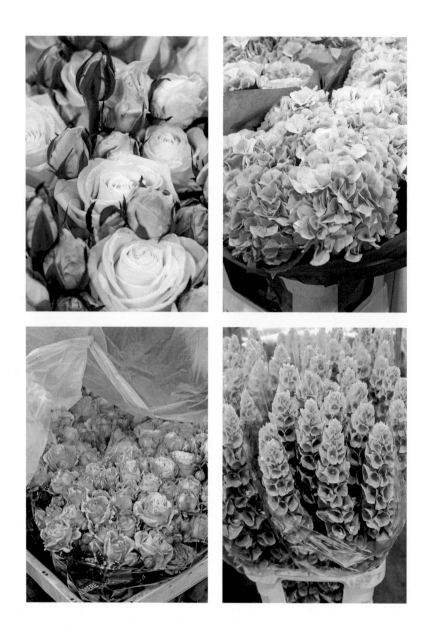

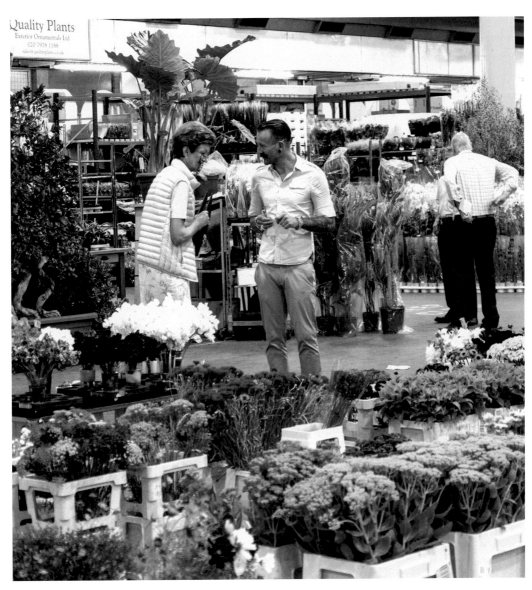

A typical June morning at the Market (ABOVE) with the stands full of colour, scent and a wonderful assortment of floral fabulousness including roses, hydrangeas and bells of Ireland (OPPOSITE). As much as for its flowers, I value my visits to the Market for the opportunity to chat with my fellow florists. Here, I'm exchanging a 'Good morning' with Mrs Waites, my erstwhile boss when I worked at Pulbrook & Gould. Like many of the faces I see here daily, she is a market stalwart and I have known her for more than 25 years.

97

Sweet peas in tins

In June, sweet peas fill the Flower Market with their inimitable fragrance and texture, be they slender, subtle, long-stemmed and deeply perfumed British-grown beauties or the more gutsy but less soulful scented Dutch cousins, which are usually longer-lasting but to me always have a slight lack of 'magic' about them. You need to do very little to show off these exquisitely delicate flowers. The simplest of containers, and an equally simple approach to arranging them, does the job to perfection. I enjoy any possible floral puns, so combining peas with sweet peas and arranging them in tin cans really tickles my sense of humour. If you want to do the same, you will need to wire the pea pods with florist's wire to create a suitable 'stalk'.

British-grown sweet peas smell magical and, though short-lasting, they look great when curated by colour in a row of simple tin cans.

1

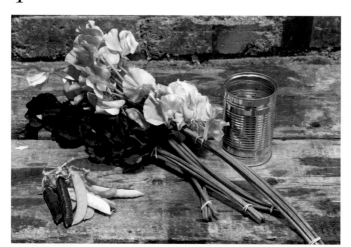

Assemble your flowers and vessels. I selected sweet peas in shades of mauve, pink and white, with some purple and green edible pea pods. You will need fine florist's wire for the pea pods 'stalks'.

2

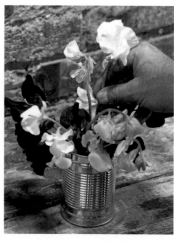

With the vase two-thirds full of water, arrange the sweet peas, shortening stems as needed, so they support one another.

6

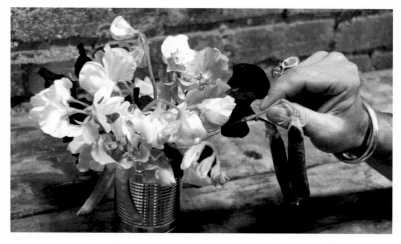

Carefully position clusters of pods around the edges of the vase, giving a fun flourish to these delicious decorations.

3

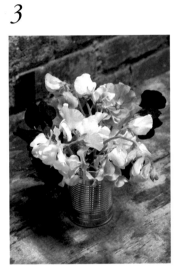

I like a curated collection of colours in each vase, but a riotous mix will look and smell just as wonderful.

4

If you want to add the pods of peas, use fine florist's wire, carefully twisted onto each of the short pods...

5

... leaving a sufficient length of wire on each pod to tuck into the vase. Wire all the pods before adding them.

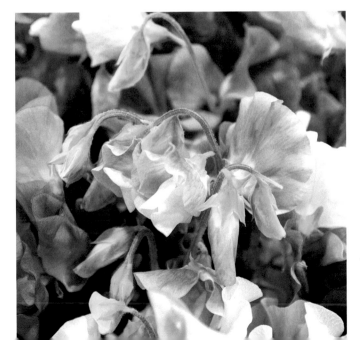

To paraphrase a well-known song...'Sweet peas are made of this, who am I to disagree?'

The Flower Market really is a village, with an entire community involved in an assortment of tasks, so that it runs like a well-oiled machine from late in the night until lunchtime the next day. While most of us are asleep, the 'night men' begin their topsy-turvy day, receiving and distributing vast trolleys loaded with flowers as they are forklifted off the pantechnicons arriving from the Aalsmeer auctions, along with the smaller trucks that bring flowers to London from across the growing districts of Great Britain. By the time I arrive at the Market around 6am, half the men and women working there are already part-way through their day, so in need of sustenance, be that a vast 'greasy spoon' style breakfast or a drink or snack from one of the trolleys doing the rounds. As I leave the Market, with vans laden, to head back to our workrooms for a flower-filled day ahead, the folk in the Flower Market are beginning to wind down.

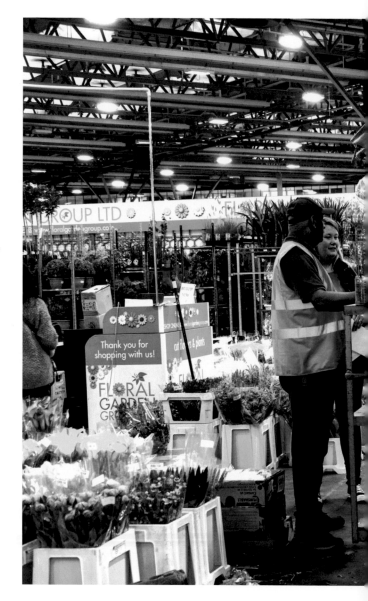

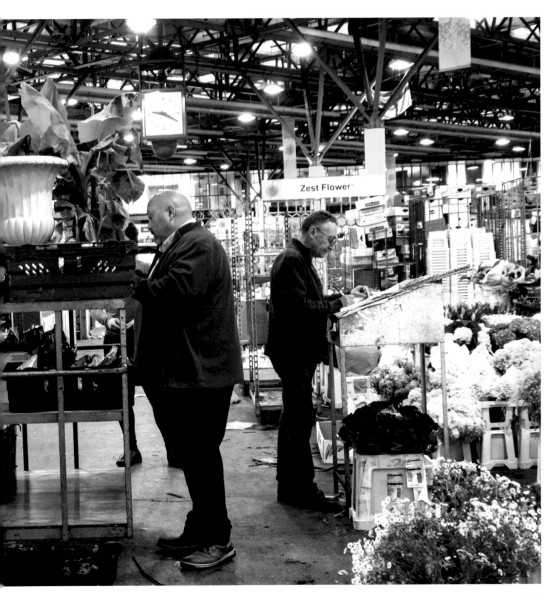

July

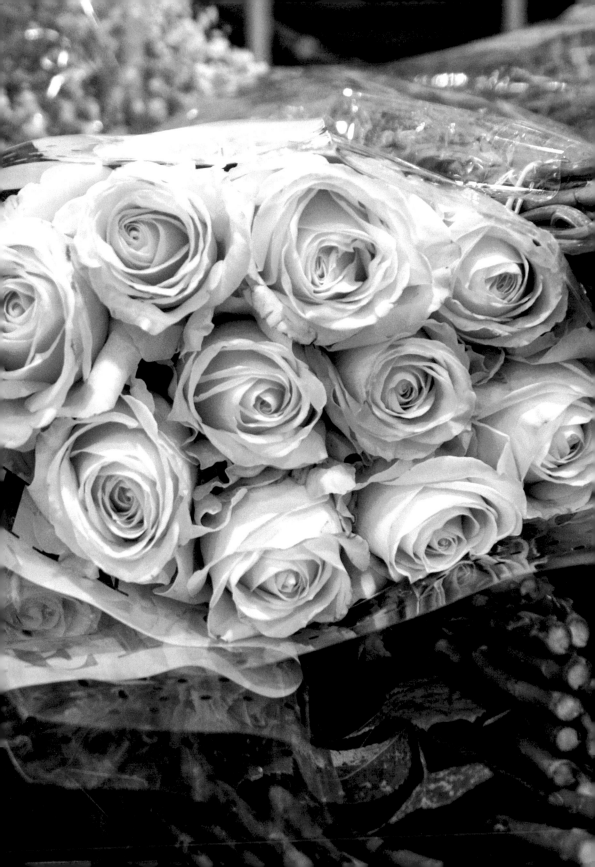

A S JUNE SWINGS INTO JULY, some of the stands that major on
British-grown flowers compete in a seasonally inspired
'colour-off', as tall bundles of cosmos in cerise and deep red-wine,
candy-pink and pristine white stand in buckets adjacent to boxes
stacked several feet tall, laden with a whole feast of flowers. The
heaviest of these will be packed with squat, bunched stocks in an
ice-cream palette among which occasional raspberry-shaded stems
create a rippled effect, and from which a really summery scent
bursts forth when their lids are lifted. While a passing waft is fine,
I find that, as these flowers mature, like hyacinths, their fragrance
becomes cloying and headache-inducing. Another seasonal treat,
but unscented, are tall bunches of larkspur in blue, white and
pink, lying alongside those of poppy seed-heads, the globular
grey-green a contrast to foamy green *Alchemilla mollis*. One of my

From July onwards, in addition to the
usual summer flowers (OPPOSITE), the
British hydrangea flowers are at their
finest and trolleys laden with them appear
in the Flower Market (ABOVE). The soft
sorbet shades of pink and raspberry contrast
with the dusky, antiqued purples and
lilacs, and some with an almost verdigris
tinge. I can take ages cherry-picking my
preferences, but the salesmen and women
know me of old and seem happy to
tolerate another fussy florist.

particular favourites at this time are the bunches of saponaria, its white and salmon pink flowers far more robust than their dainty appearance would suggest. On some stands, boxes of them will be found lying in duvet-like contrast to spiky stems of *Echinops* and *Eryngium* thistles.

On the foliage suppliers' stands, amongst tubs filled with tall stems of forsythia, privet and viburnum with unruly tails of ivy, bundles of garden hydrangeas are packed onto trolleys – tonal treats in pink, mauve, green and blue hues. They often arrive at Market heaped into the back of scruffy vans and estate cars, tied into short-stemmed bunches with orange bailer-twine by regulars who bring other unexpected treats like arching stems of artichoke leaves and armfuls of scented geraniums (*Pelargonium*).

At the Flower Market, some stands, such as Dennis Edwards', always have a few 'specials' – buckets and trays of unusual items (including the artichokes overleaf) – and are one of the reasons why, 30 years on, I am still just as enthusiastic about going to the Market. Dennis was the first person to ever serve me when, as a timid 20-year-old, I ventured into the Flower Market for the first time. Dennis was then, and still is now, a Flower Market institution, always going above and beyond to find the very finest flowers and foliage, and ever in search of the unusual and the innovative, wanting to offer the largest, the biggest and the best blooms in the building. Born in Drury Lane, he has worked in all three of the Flower Markets, firstly in the original Covent Garden Market, then, when it moved in 1974 to Vauxhall, in the New Covent Garden Flower Market and now at the current (interim) market site a little further along Nine Elms Lane. In 2022, when all development is complete and he moves into the new New Coven Garden Flower Market, he will be a record breaker!

The sense that summer is properly upon us only dawns on me once the schools break up and when the British-grown dahlias start to arrive at the Flower Market. While a rather unsatisfying assortment of these highly prized flowers has been available from Holland for a couple of months, their true flowering season is

shown by the dramatic and dynamic blooms that start arriving
into the Market in late June from British growers and continue
to dazzle us each morning till the first frosts. From pristine and
perfect pompoms to sea-urchin-like, cactus-style flowers, dahlias
in all their fabulous forms have a colour palette as varied as it
is vibrant, and I adore them all. A couple of the Market stands
have private growers who send buckets brimming over with
short-stemmed selections in jewel-bright shades of pink and
scarlet, mauve and purple, and orange with pops of acid yellow.
There is always a rather pleasing element of 'pot luck' to the
palette of colours that arrive into Market. Even having expressed
a preference, it's always a case of 'picker's choice', and it rarely
disappoints! In fact, the colour combinations of the flowers sitting
in their buckets in rows on market trolleys are inspirational.

Other growers specialize in true show-stoppers, sold either
as single stems or in stately bunches, often a metre tall and
sometimes with heads the size of dinner plates. Luscious and
multi-layered heads, weighted with massed red petals tipped with
yellow or orange splattered with crimson, crowd out buckets
alongside spiralling, petal-packed blooms in crisp coral, purple
and deep mauve, and water-lily-like flowers in sorbet shades of
soft apricot, pale pink and peach, and occasionally deep velvety
scarlet. The massively on-trend 'Café au Lait' lords it over them
all, the flowers always dreamy to behold and challenging to
arrange as they stubbornly sit flat side on to the stem leaving you
with little option but to let them settle at will in any decoration.
For all their trouble, like an overly generous yet cantankerous old
aunt, they bring so much to any arrangement that they are to be
tolerated at any cost.

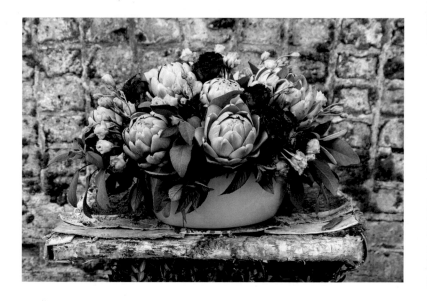

Artichoke bowl

Whenever I see artichokes in the Flower Market I'm immediately tempted! At certain times of the year, precarious buckets are laden with tall-stemmed specimens, their chokes bursting forth to reveal the silky tasselled interior. Delicious to eat and dramatic to use in decorations, the architectural artichoke can be a bit of a bruiser in floral arrangements so needs firm handling, sound mechanics and a set of contrasting bedfellows to enhance and contrast, and to prevent anything too heavy resulting from your labours. When using such weighty material, it is essential to have mechanics that are strong enough to support and sustain the arrangement as its created and to ensure it holds together for the period required. Smaller non-edible varieties come in bunches and are easily used as taller treats arranged within larger designs, although again they tend to be top-heavy so require an equally weighty vase. Trays of short-stemmed varieties, which are often sold in greengrocers too, are perfect for using in garlands and low, mounded styles of arrangement, such as this bowl with Mediterranean herbs and some stems of tonally pleasing lisianthus flowers.

A wonderful assortment of purple and violet foliage and flowers is contrasted with the architectural elegance of glorious globe artichokes in this mounded decoration, the softness of the scented sage acting as a counterpoint to the heft of the artichokes. I love using the scented sage foliage, in shades of purple and green, as its glaucous colour and slightly felted leaves give an added dimension of texture and tone.

110

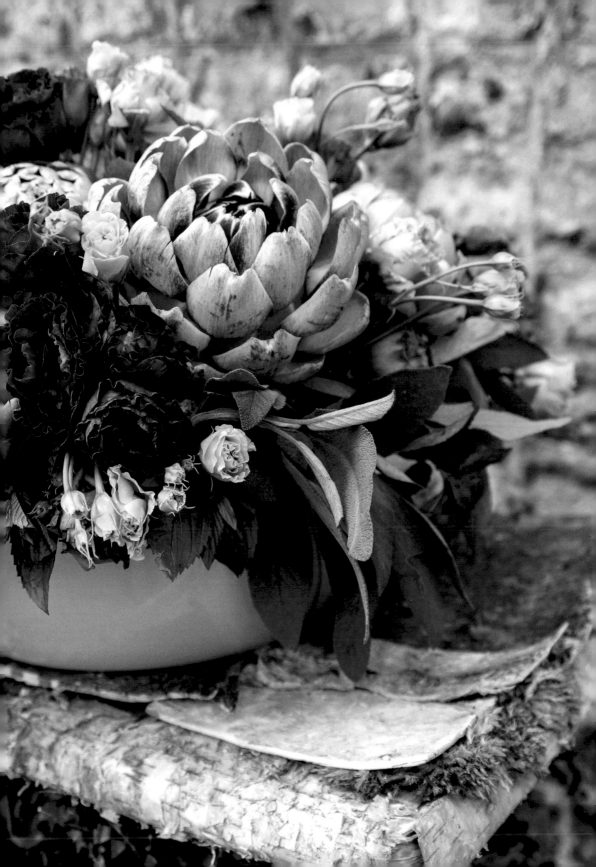

1

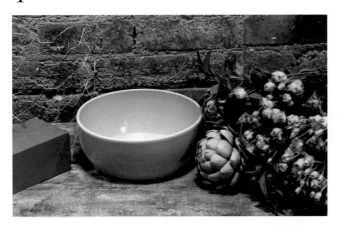

Assemble your plant materials and chosen container. You will also need a block of flower foam and a square of 2in/5cm chicken wire, roughly twice the size of the opening of your container (for a 10in/25cm bowl, use a 20in/50cm square of mesh) and florist's reel wire.

2

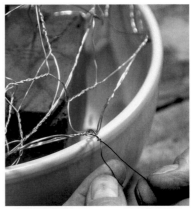

Put the foam in the container base and cover with chicken wire, corners pointing inwards, to form a mound. Secure the chicken wire to the container with reel wire.

5

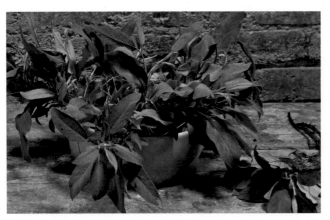

Soon the mechanics will be nicely shrouded by the greenery. As you work, be careful to make sure all the cut stems are fully pushed into the foam or into the wire and water around the sides. Some stems are left slightly longer to flow over the edges of the container for a softening effect.

6

Using bunches of different foliage (I've used mint), add stems, again in small clusters to give a grouped effect rather than dotted about, tucking them into the foam or mesh.

3

Use the reel wire to secure the mesh to the container, as you would string a parcel, passing it beneath the bowl from side to side. Ensure that your wire is securely fastened to your container as this decoration will be pretty hefty. Fill the bowl one third with water and allow the foam to absorb it, then add another dribble to the bottom of the bowl.

4

Cut a few stems of the sage foliage between 6–8in/15–20cm long, bunch them together, and push them through the network of chicken wire into the foam.

7

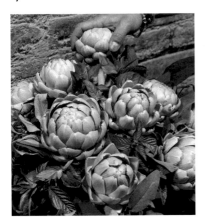

Cut the artichoke stems to about 8in/20cm. Gently push each one into the foam until it is securely supported and to create a mounded effect.

8

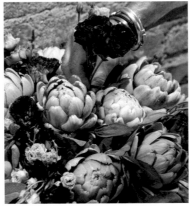

Add in some stems of lisianthus flowers in small clusters to create a pop of colour and a tapestry of tones and textures, inviting your eye to explore and enjoy this visual feast.

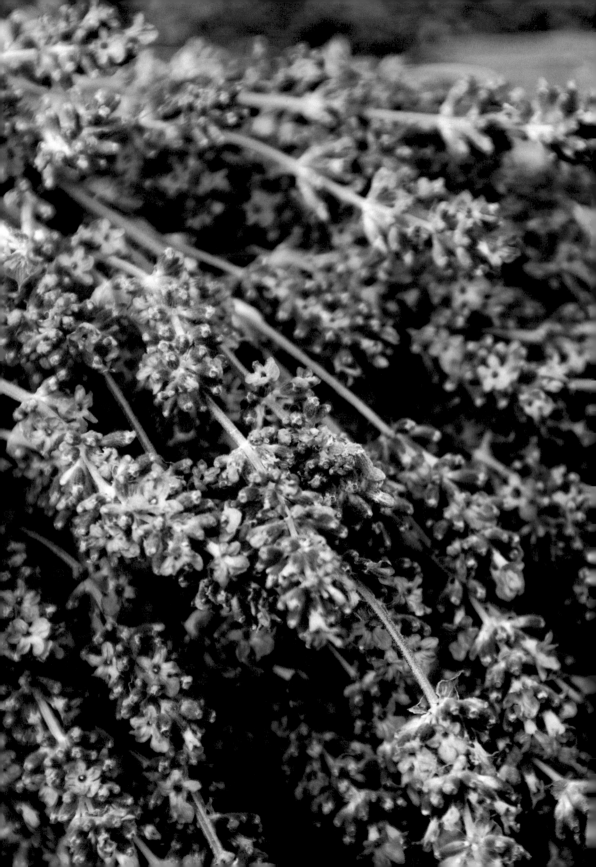

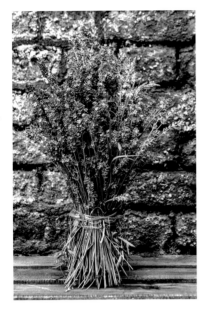

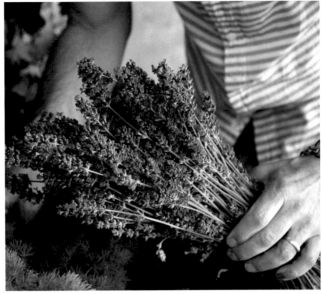

Lavender

My paternal grandmother lived a short walk away from my childhood home in a bungalow, the front garden of which was surrounded by a broad hedge of lavender. In my recollections, her lavender hedge seemed always to be in full bloom and a-buzz with bees. Harvesting the lavender to weave it into little bundles or dry for lavender bags was an annual summer ritual which usually took place prior to the family holiday at the end of July. Now when I see the scented sheaves of lavender flowers appearing at G.B. Foliage in New Covent Garden Market, it is a sure sign that we are halfway through the year. Kent and Hampshire send wonderful boxes and bunches of lavender to the Flower Market during June and July. As it is pretty weather dependent, it has a relatively short window when it's at its finest, adding a magnificent startling blue hue to our arrangements. Picked too soon, its full floral potential is never quite achieved; left too long, its buds will drop, scattering fragrant yet fiddly-to-gather purple-blue sprinkles for miles, especially if the surface beneath happens to be a white tablecloth. But its fragrance is incredible and it still stops me in my tracks.

If you are able to find a bunch of freshly gathered lavender, snap it up. Even if you do nothing more than sit it in its bailer-twine-wrapped bundle on your table for a few days, it will scent the air and gladden the eye. When it starts to shed, simply let it dry completely and crumble its flowerheads into a bowl for a year-long fragrant treat.

115

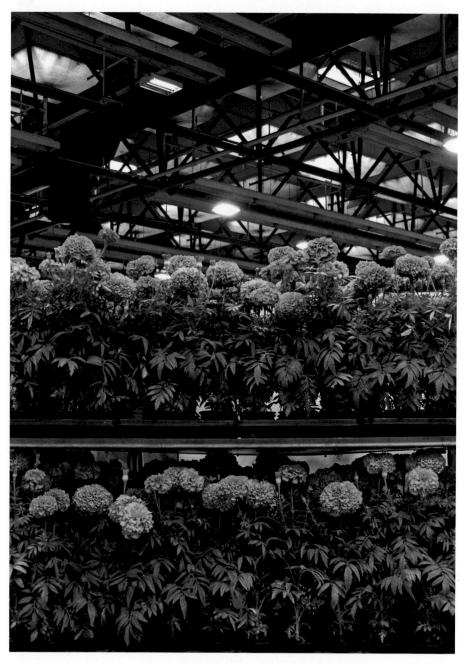

*Even quite mundane flowers make a spectacular statement en masse, like this trolley
laden with French marigolds* (ABOVE) *or cute bunches of anthuriums* (TOP RIGHT).
Dutch discoveries such as Asclepias tuberosa *need to fight to be noticed as a new
kid on the block when up against stiff competition from old favourites.*

116

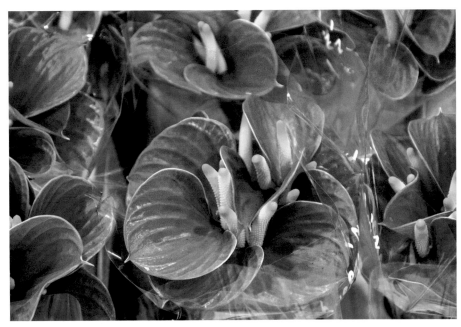

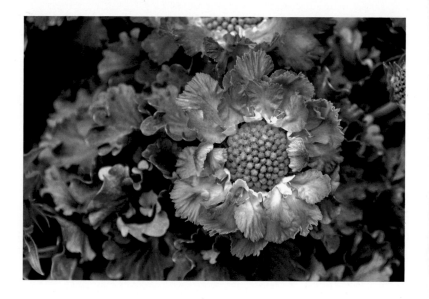

Scabious posy

When I first became entranced by all things floral, at the age of seven, it was at a summer flower show in my home town of Warwick, and I can, even now, remember the various vases on the show benches filled with abundant garden blooms, including stems of what was an unknown but elegant, soft-summer-sky blue with ruffles of ombré petals surrounding a central button of little buds. I was delighted by them but disappointed to know they were called scabious – such an ugly name for such an elegant and effortless flower which would be a perfect prototype for a flower fairy's tutu! They are another flower well grown by both Dutch and British suppliers and for me a real taste of summer. During July to September, into Market arrive beautiful bunches of 'cottage' scabious, the smaller-flowered country cousin, which are easy enough for even me to grow and which look glorious when added to hand-tied posy style arrangements as, like their bolder blue relatives, the flowers are born aloft on surprisingly strong yet slender stems, enabling you to create a wonderfully multi-layered mélange of flowers when threaded among heads of hydrangeas and finished with a frill of hosta leaves.

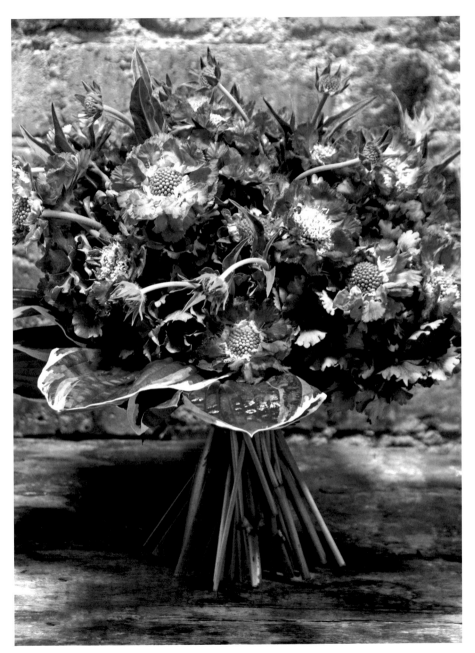

A sense of abundance is easily achieved across the flower year and especially during the summer months if you select flowers in season. The beauty of creating a tied posy arrangement is that as you are working with the flowers you have the opportunity to inspect and enjoy each bloom in its petalled perfection. With a little practice, a well-balanced hand-tied bunch will stand on its trimmed stems, a wonderful party trick with which to impress your fellow arrangers, before you pop it into a vase.

1

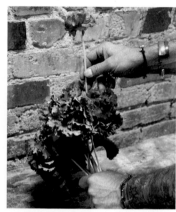

Assemble your plant materials and a reel of twine, raffia or paper-wrapped binding wire. Prepare your flowers by removing any side stems and most of the lower leaves before you do anything else as one hand will be used as a 'vase'.

2

Using the hydrangea heads as support, thread the scabious stems through them. Continue to build with some scabious stems slightly longer for a domed effect.

4

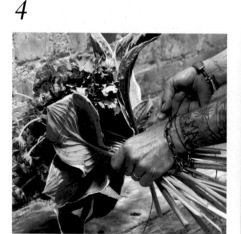

Using some twine or paper-wrapped wire to hold them in position, continue to add in more leaves as you gently turn the posy in your hands, creating an even, surrounding collar for the posy.

5

Using one hand as the 'vase', adjust the shape with the other. Once all is looking good, tie the twine or paper-wrapped wire around the stems to secure the posy.

Heads of hydrangeas act as a superb support to softer and lighter flowers, such as astrantia or astilbe, or, as here, stems of British scabious. The technique works well with flowers throughout the seasons but is particularly useful when supporting more delicate summer blooms.

3

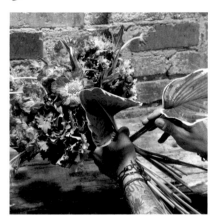

Create a supporting 'collar' using stems of foliage or leaves. Begin by placing the hosta leaves in clusters around the posy, with the base of the leaf tucked in beneath the flowers.

6

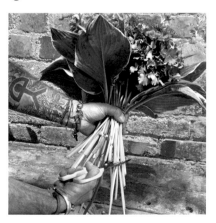

Trim the ends of the stems into a tidy sheaf, short enough to ensure even the shortest of stems will be within water once placed into a vase.

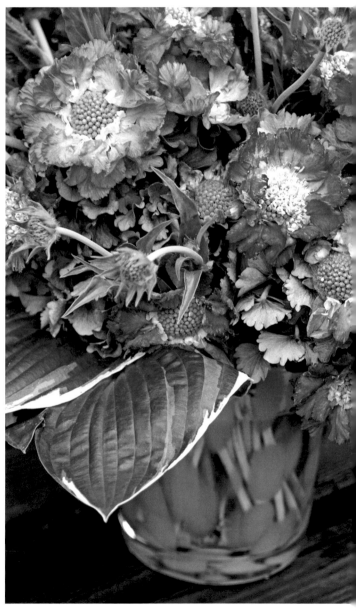

Roses and rosebuds

My parents' Warwickshire garden was bordered along one side with climbing 'Albertine' roses that produced scruffy and multi-layered, light pink flowers which were unbelievably fragrant and which adorned the fence with tissue-paper-pink blooms throughout all of June and July. Occasionally my mum would pick some and pop them into an old blue and white Delft vase which, to this day, sits upon her kitchen windowsill and is her vessel of choice for a few garden-gathered stems. This was, and still is, the extent of her flower arranging, and so it's a mystery to me where my passion for floral decoration came from! That being said her style of arranging is all that anyone ever really needs: the eye to pick a few favourite blooms, buds and stems, place them in a water source and enjoy them.

It seems strange that my childhood memories of a few stems of rambling roses resulted in this feast of flowers gathered from the Flower Market. But often it takes just one stem to spark a memory that will scroll me back over 40 years, as well as inspire me to create something new. Isn't it odd how flowers and fragrance have that power?

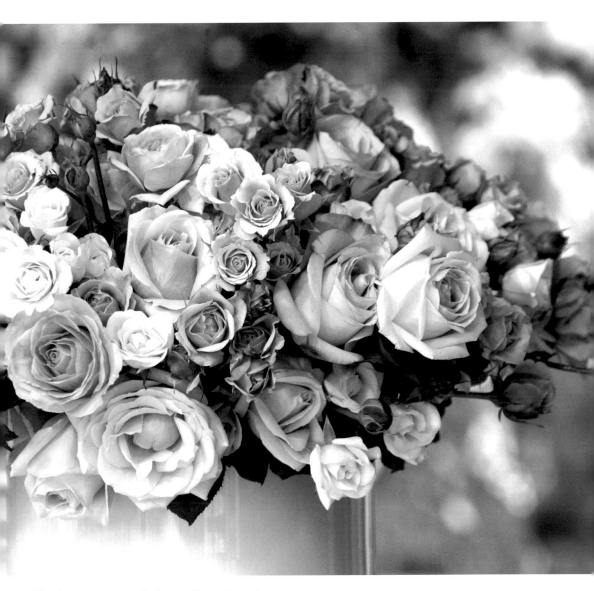

This decoration is in a style that our clients adore, using an abundance of gorgeous flowers in a curated palette to create a wonderfully layered effect. The absence of any foliage other than the leaves on the assorted rose stems may be a decadent design concept but it results in a beautifully blowsy bowl filled with beauty, drawing the eye in among the flowers, and sparking memories.

August

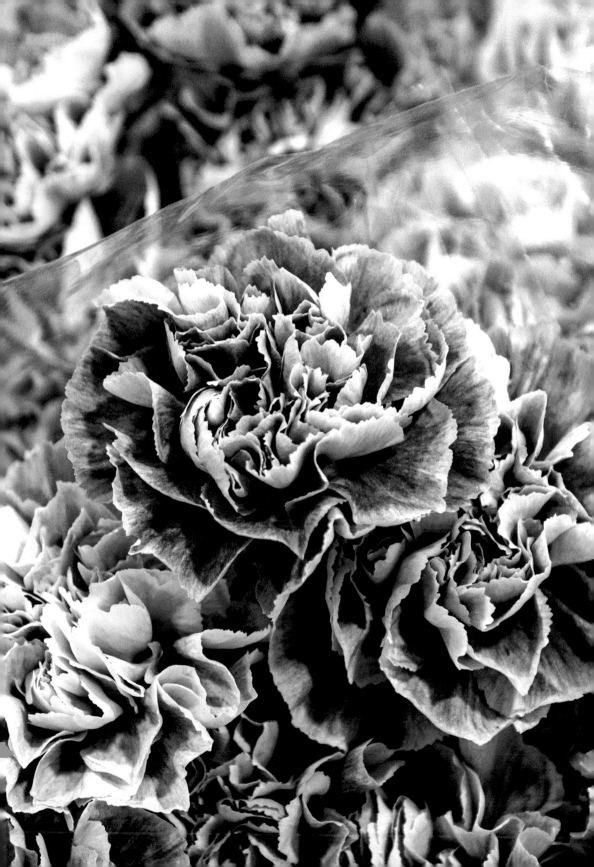

M Y ALARM JOLTS ME from 'comatose sleep' to 'up and at it' at least five mornings a week, usually at 5am, so to set it any earlier feels like a major imposition. Nonetheless, each August – usually the first Friday in the month – I set the alarm for 3am, knowing that I am about to head off to the west coast of Scotland. N's family have a house on the shores of a sea loch, overlooking the Isle of Mull, and it's to this isolated and remote part of the world that we disappear, usually for an entire month. The majority of our clients go away the moment the private schools break up in July and, with less and less corporate entertaining taking place as Britain follows France in almost closing down its major businesses over the summer, it's a great time for Team Lycett to recharge batteries and catch up on sleep, on social and family time. Safe in the knowledge that my brilliant team will be coping with any events that are scheduled in my absence, N and I load the car with clothing for all weathers, abundant supplies of drink, a stash of Ottolenghi-inspired ingredients and Stan the dog, and by 4am we are well on the road. By 10am we are usually in Cumbria, amongst scenery to gladden the heart, and, by noon, the majesty of Glencoe will have my eyes welling with tears, awestruck as I am each time I drive through the vast, cathedral-like magnificence of the natural landscape.

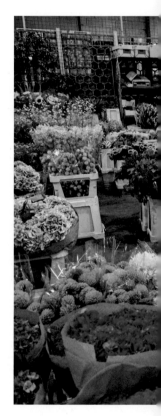

The roads narrow as we approach Fort William, and soon we are in line for the Corran ferry and sending our last text and WhatsApp messages before crossing Loch Linnhe and arriving on the Ardnamurchan peninsula, where foxgloves and rosebay willowherb crowd the single-track roadsides, and where mobile telephones struggle to receive signal... perfection! As we drive towards our Highland escape we pass the tiny village of Ardgour,

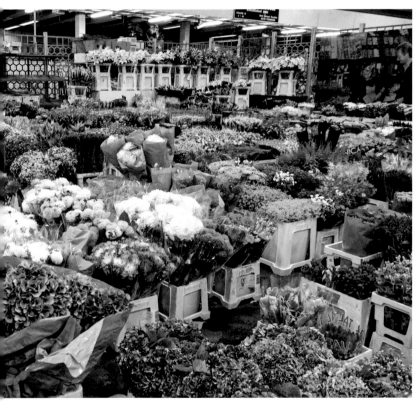

The Flower Market is filled to bursting with a richness of flowers and foliage in all shades and types, from muted hydrangeas and clashing dahlias to bright zinnias, by the time the summer is at its height in August, and just as I am about to escape for my summer holidays.

where the great and iconic Constance Spry had a holiday house until the late 1960s. It makes me chuckle to think that I'm finding my quiet time in the same area and climate as the woman who was the 'grandmother' to all florists: the society floral decorator commissioned to design the flowers for the coronation of Queen Elizabeth. And the woman credited with creating that icon of English 1950s' picnics, coronation chicken!

By early afternoon the car is unpacked and we are settled into the former Victorian laundry to the local Laird's castle, which,

since its conversion in the 1940s into the most magical of holiday homes, has been a place of unbelievable peace and calm.

On an exposed hillside overlooking a sea loch, the grounds of the house are more semi-tamed wilderness than garden. The tide of bracken and brambles which used to annually engulf the entire space is now held in check by banks of *Rosa rugosa* and *Rosa rubrifolia*. These we planted over a series of years and slowly they have taken hold, together with drifts of crocosmia, to reward us each summer with bold cerise or pure white rose head, and vivid jewel-like hips, to contrast with the bright swathes of flame-hued flowers wending amongst the ferns.

Other gardens locally look very similar, with hydrangeas, rhododendrons and azaleas and a few brave rose bushes providing punctuation among the masses of crocosmia, hardy fuchsia and hypericum with occasional bursts of broom. However, there are also a few wonderful community gardens and growers who sell their excess vegetables, fruit, salad and flowers. One of my favourite and frequent trips while here on holiday is to visit local growers to collect armfuls of delicious, freshly harvested organic produce, including punnets of raspberries, prickly cucumbers, the sweetest of beetroot and tomatoes, and the most fragrant of herbs and scented sweet peas.

BELOW LEFT AND OPPOSITE *A corner of the gardens around our holiday retreat with the sea loch beyond.* BELOW *My Scottish summer floral decorations are always simple and seasonal, inevitably featuring bright orange crocosmia (which flourishes like a weed on the lochside wildernesses of the West Highlands) or glossy rowan berries, symbolic in Celtic mythology of the Tree of Life.*

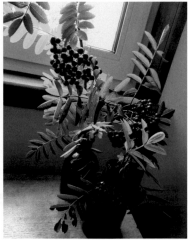

Every day we enjoy dog walks and picnics on deserted beaches
or windswept hills, and at every turn the abundance of nature
is breathtaking, with spires of flowering foxgloves and rosebay
willowherb, trails of the most sweetly scented honeysuckle, bold
daisies and cloyingly pungent meadowsweet.

In the house, I fill the rooms with jugs of foraged ferns and
grasses, branches of berries and clusters of thistles, and lichen-
encrusted stems of larch. But of everything that grows so vigorously,
I am most taken by the beauty of the ferns and especially the mosses.
Deep within the ancient oak woods that fill the hills and valleys in
this part of the West Highlands, the assortment of ferns that clothe
the trunks of trees, both living and dead, are only rivalled in their
lushness by the deep duvet-like drifts of moss. Regardless of the
weather, which can be mixed at best, time spent wandering in these
amost primeval forests is always tranquil – a perfect counterpoint
to walking on windy beaches or rootling among rockpools, where
other treasures, such as sweet, juicy mussels, abound.

Scottish medley

My lucky and lovely summer on the west coast of Scotland is for me a
very different flower month. We leave London with a house-sitter to
care for the garden, where our summer flowers are in full floral tilt (and,
inevitably, where our first tomatoes are ripening just as I begin to pack!)
and head off to the Highlands. Here the summer flowers are usually
only just starting to bloom and the varieties to be seen are a much more
edited assortment.

The garden of the house where we stay is rudimentary but
has a plethora of *Rugosa* roses, crocosmia, ferns, hardy fuchsias and
hydrangeas, with occasional Japansese anemones. Despite being old
and draughty, the house is always filled with plentiful food and drink,
love and laughter as we adore having people join us for a few days of
Highland fun. So I make sure there are fresh flowers by bedsides and

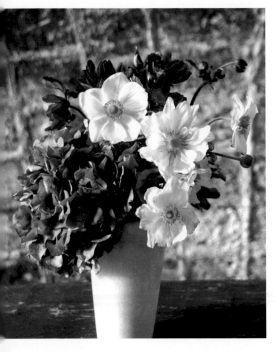

in sitting rooms to distract from the odd damp patch
and the absence of en-suites! By necessity these
decorations are relatively simple and are foraged from
the garden foliage and flowers, augmented by some
locally grown flowers, such as sweet peas and cosmos,
marigolds and cornflowers, and dahlias and dianthus,
either from the local community gardens or from the
fabulous organic grower from whom we buy all our
vegetables, salad and soft fruits.

Often the arrangement can be as naïve as single
stems plonked in a vintage bottle or a battered china
mug, but each gives me as much joy as any of the
hothouse-flower filled confections we create at Lycett
Towers for our clients.

1

Assemble your plant materials and a suitable vase or vessel. Fill the vase two-thirds full of water. Remove any ties from all bunches.

2

Cutting the stems as usual on an angle, trim the hydrangea to be just proud of the rim of the vase and make a small split up the stem. (Always cut and split any hardwood stems to help them take up water.)

3

Remove lower leaves from any flowers that you are adding as they will swiftly turn the water to a smelly soup. Plonk them into the vase and adjust until they fall into a pleasing position (or coerce them to be where you would like).

4

A few stems of a contrasting-coloured flower give a change in tempo, as this type of decoration is made by the sum of its contents, so any odd sprigs of foliage and stems of flowers will give further interest.

Simple Scottish jars

Less can be more! Possibly the least flower-filled of all the decorations that I create during my floral year, these arrangements, which are never more than a couple of prized stems of flowers, seed-heads or leaves, and the assortment of containers, be they a bottle, jar or glass, along with the pebbles, are all part of the minimalist charm.

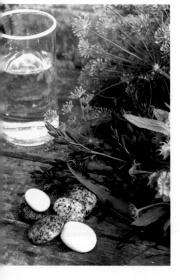

My greedy, month-long summer holiday in the Scottish Highlands takes me away from the Flower Market and from the day-to-day frenetic and meeting-filled days that generally make up my working weeks across the year. For the first few days I am happy to simply sit and stare out at the ever-changing light upon the sea loch which laps at the bottom of the garden of N's family home in Scotland. However, after catching my breath I'm ready to welcome friends who join us in what is, to me, one of the most magical of places, largely due to its untamed and wonderfully wild landscape. Being on the west coast, the weather is often wet and, though not frequently sub-zero, for long winter months it's a damp and dark place to be, so all growing is a challenge. I'm lucky to have a few wonderful local community garden schemes which, in addition to producing bags of the freshest of produce, also have a few rows of flowers and herbs which they will cut and sell in local honesty-box shops. I now know the locations of all these rustic retail outlets and will literally accelerate the car as I approach, hoping to head off any rare passing traffic and beat them to get the pick of the crop! It's not unusual for me to buy the entire bucket filled with bunches of dahlias and cornflowers, marigolds and dill, rudbeckia and dianthus – favourites across the peninsula in gardens that are more tolerant of the often-challenging weather. Having sometimes managed to score many bunches but, just as frequently, only a few stems of flowers, I enjoy adding pops of colour throughout the house in readiness for arriving guests. None of the arrangements is complex and many feature vases or vintage vessels found in the house (some of which have been in the family since the 1940s) along with the addition of the odd lovely pebble or shell picked up on our daily walks along a deserted beach.

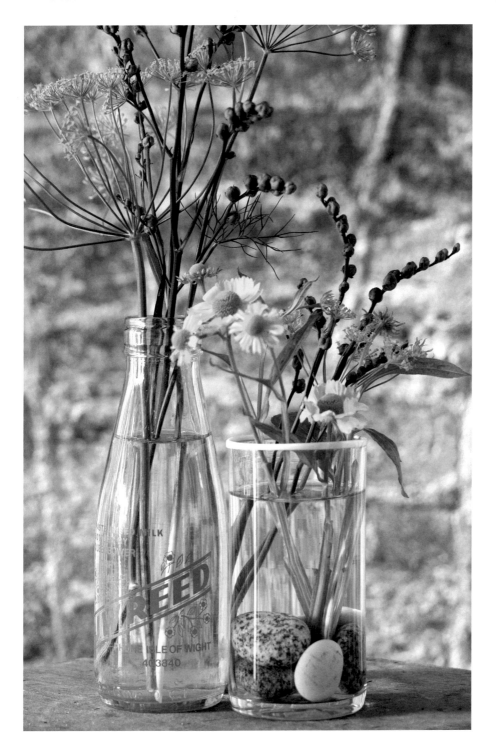

Oak and fire

This turned-wood vase, created by a local sculptor, was spotted in a nearby Highland gallery. It contains the very essence of my month on the west coast of Scotland. Stems of vivid and vibrant crocosmia, in all its stages, from emerging flowers to stark seed-heads, combine with clusters of oak leaves, some with a hint of autumnal hue. It truly is my summer in a vase!

The house we visit each August has a sea loch on one side and magical, ancient oak woods on the other three, and sits within a wild garden of ferns, *Rugosa* roses, hydrangeas and great swathes of crocosmia, which has colonized the grassy banks and hillside. When in Scotland, on an almost daily basis I gather stems of its fiery bright orange flowers and the equally statuesque seed-heads, and fill great jugs with them to brighten dark corners. The oak woods, full of mosses and ferns looking like they were at the very heart of Middle-earth, are so rare that it is forbidden to forage among them. However, the banks and hillside within the grounds of the house also have mosses and ferns aplenty, as well as birch and beech trees, rowans and hazels. All of them grow prolifically in the mild, wet summers, so usually an armful of the bright orange crocosmia is accessorized with some verdant green foliage, the perfect backdrop for an explosion of colour, replicating in miniature what lies beyond the window and leading the eye to the waters of the loch below.

September

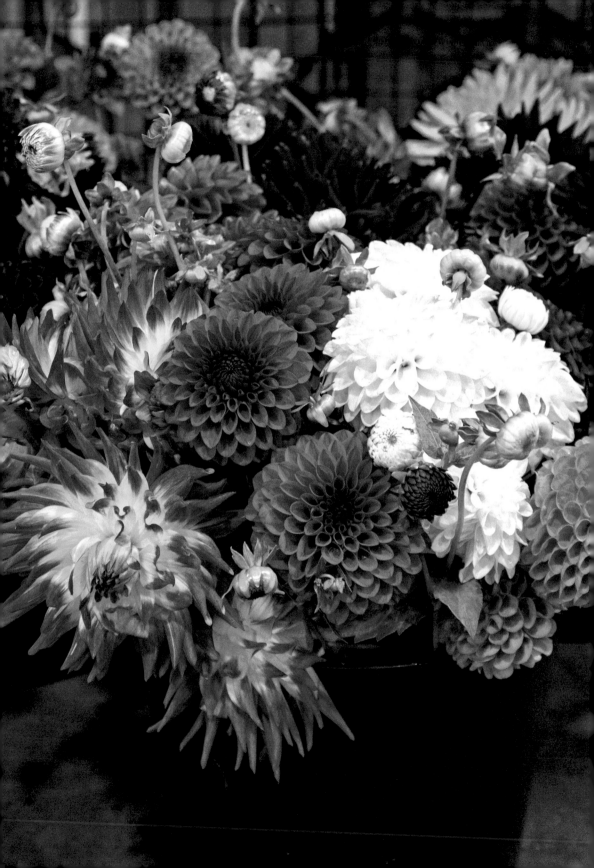

IF ANYONE ASKED ME which month I would recommend for holding a wedding after May (with its explosion of fabulous flowers including the late-spring and summer bounty that I greedily feed upon as a florist), a close runner-up would have to be September. Almost everyone feels rested, the weather is usually warmer than June and the Flower Market is bursting with an embarrassment of riches.

After my indulgent month on the west coast of Scotland, I return to London and to the Flower Market, to be greeted by an almost magical assortment of foliage and flowers – buckets of dazzling dahlias still appearing among the swathes of cosmos and echinacea, bulging boxes laden with brilliantly bold asters and chunky sunflowers, solidaster and solidago. The most fragrant of garden roses still arrive almost daily from Dorset and from further afield, the weather impacting hugely on what is delivered each morning. After a wet summer, the British-grown roses are a rare find and are augmented with those grown in polytunnels in either this country or overseas, some of them even having been flown in from Kenya.

Just as the flower stands are brimming over with colourful offerings, so, too, are the foliage stands. Depending on how hot the past few months have been, the assortment of foliage in September can take on a really autumnal hue, with beech and oak beginning to turn, along with viburnums and rowans laden with bright berries, and with sheaves of golden grasses and bundles of corn, wheat and barley. Crates of crab apples begin arriving, along with gnarled and warty gourds, assorted squash and pumpkins – a sure sign that Harvest Festival and Halloween are lurking around the corner!

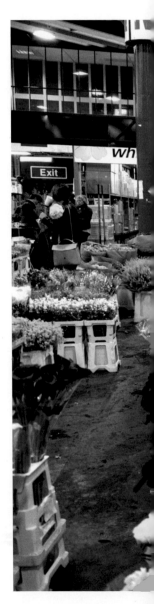

*Colour abounds across the Flower Market in September, with
the orange tones to the fore, but still with a late summer rather
than autumnal air, although the moment the hop bines begin
to arrive from Kent, and are draped around the stands by some
stallholders, the air begins to smell distinctly seasonal, and
summer rapidly feels a distant memory.*

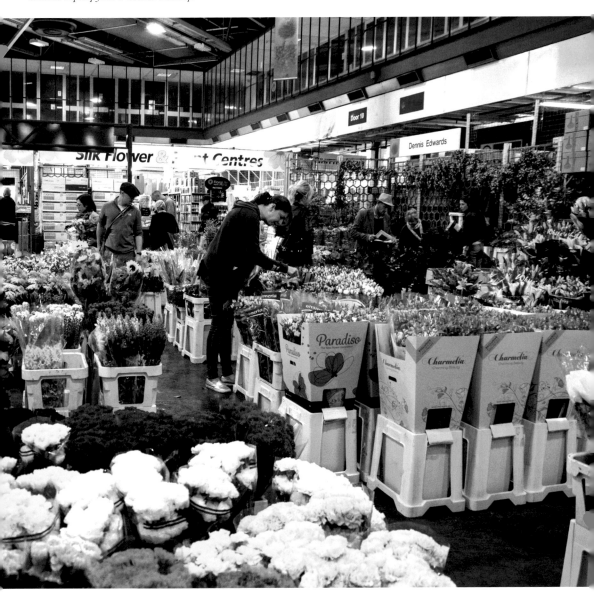

Occasionally one or two of the stands will have some
buckets containing bunches of blackberries, cut and tied into
lethal yet lovely seasonal treats. They always remind me of the
days when I was a new-to-London junior florist and worked
for the late, brilliant floral genius Robert Day. As a kid who'd
lived all his life in Warwickshire, where the September hedges
and verges were thick with brambles, as we called them, I found
it quite extraordinary that anyone would actually pay to buy
bunches of them. When I worked at Pulbrook & Gould, stems of
blackberries sold for the same price as spray roses and I will never
forget the posies and arrangements created by the workroom
there, featuring jewel-like bright berries glistening amongst
stems of 'Oceana' and 'Doris Ryker' roses.

Having left Pulbrook & Gould to become a freelance
florist, I started to travel about the country, as much of my work
was outside the City. For several summers when visiting my
family in Warwickshire, or staying as I often did with friends in
Northamptonshire, I used to fill the boot with anything I could
gather from friends and family and sell it to one or more of the
foliage suppliers in New Covent Garden Flower Market. The
stems of blackberries that I cut and bunched used to pay for my
petrol each week, and the car tax was funded by the branches of
roseships, damsons and wild apples that I crammed into the car
before heading up the the A40.

Uplifting to behold on any occasion, during September the buckets of
*mini and midi sunflowers (*OPPOSITE*) which appear in the Flower Market*
look like bunches of sunshine and are a gloriously striking flower, adding
a perfect pop of colour, with their shiny, sticky brown centres laden with
*seeds. Glistening berries, too, are a September stalwart (*ABOVE*), great for*
those of us wanting to add textural interest among assorted blooms.

141

 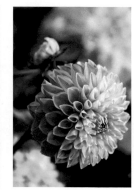

Dahlia fanfare

The sense that summer is properly upon us only really seems to dawn on me when the British-grown dahlias start to arrive at the Flower Market. They come like the circus rolling into town, with a spot of Carmen Miranda and Carnival thrown in for colourful good measure. From pristine and perfect pompoms to sea-urchin-like, cactus-style flowers, and the now ubiquitous nude-toned 'Café au Lait', the dahlias in all their fabulous forms combine a colour palette as varied as it is vibrant, and I adore them. A couple of the New Covent Garden stands are supplied by private growers who send buckets brimming over with short-stemmed selections in jewel-bright shades of red and scarlet, mauve and purple, and with pops of acid yellow as a contrast to orange- and cerise-splashed varieties.

Just a few stems of seasonal berries and seed-heads, such as spindleberry, amaranthus and cotoneaster (ABOVE, from left to right, with a pompom dahlia), make the perfect vase-fellows for some eye-catching dahlias (OPPOSITE).

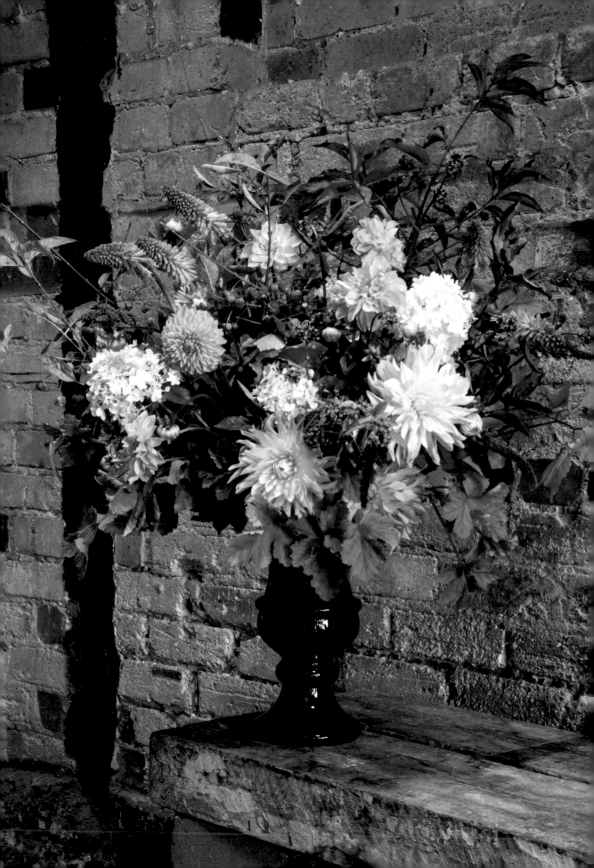

*This festival of texture and colour demonstrates some of the seasonal
bounty in September's Flower Market: trays laden with knobbly gourds
– the uglier the more popular – glistening bunches of berries and peppers,
and top-heavy corncobs still on their stems.*

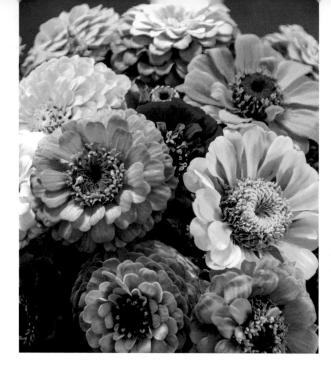

I can't resist the lure of a few mixed bunches of zinnias whenever I spy them in the Market, loving the chaotic colour combination that allows for spectacularly unsubtle arranging. Perfect for late summer parties, they lend themselves to simple mounded and massed arrangements, and need little to augment them other than perhaps a few stems of scented herbs.

Zinnias and mint

Much to my engineer father's horror, as a small child I was given a kit with which to create an assortment of flowers. While not 100 per cent botanically accurate (and made of plastic!), there were stalks of varying length and thickness, a mixture of frilly stamens and pistils, and assorted styles and shapes of petals. And, in unsubtle 1970s colours, there were petals that slotted in sets to form full-blown blooms, including dazzling daisies. They kept me occupied for hours longer than the rusting Meccano set my father had unearthed from the loft! Now, every time I set eyes on a mixed bunch of zinnias my mind races back to those clumsy plastic posies I so much enjoyed creating, as the seemingly random petal patterns and crazy colour combinations of the real thing are a dead ringer.

The colour palette of zinnias varies enormously. With their arrival into the Flower Market from some of the small British flower growers during August and September, the bunches of the most outrageouss colour combinations are snapped up almost as soon as they are unloaded from the trolley. Irresistible and exciting to behold, be they in a bucket, bunch or floating in a bowl, they shout fun, sunshine and summertime – happiness in floral form!

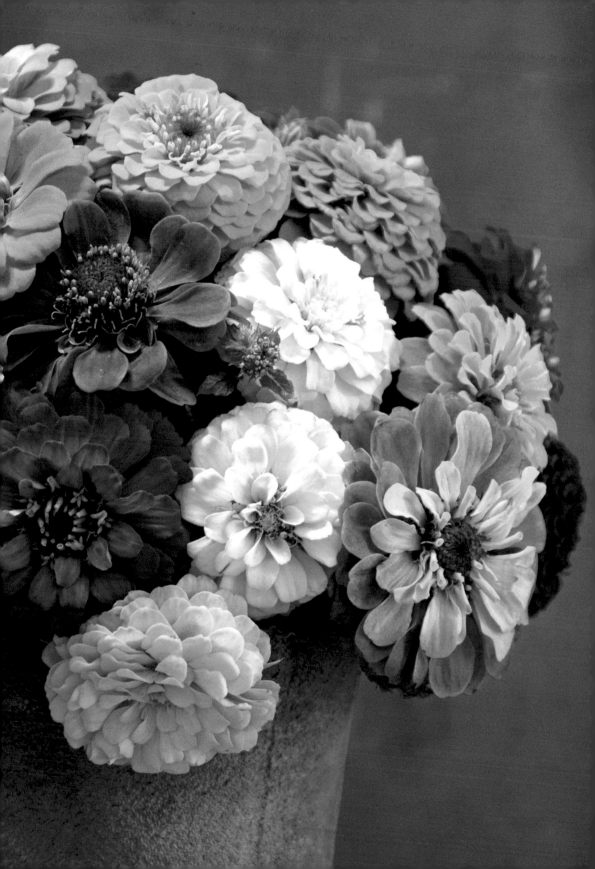

1

Assemble your plant materials and chosen container, and select a sphere of flower foam to fit as a dome inside the chosen pot. Fill a bowl with water and allow the dry sphere to gradually sink as it absorbs water.

2

Wedge the foam into the top of your container ensuring more than half of the sphere is visible and usable. Using leafy foliage, such as mint, prepare short sprigs about 3in/8cm long. Insert into the foam.

3

Gradually arrange clusters and groups of mint sprigs across the foam, roughly concealing it. Use a mixture of stem lengths and leaf sizes for pleasing contrasting coverage.

4

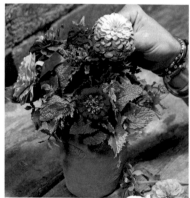

Add in the zinnias, one at a time, cutting the stems on an angle with sharp scissors. Holding the stems like a dart at the cut end, gently ease them into the foam, ensuring they are inserted by a good inch.

5

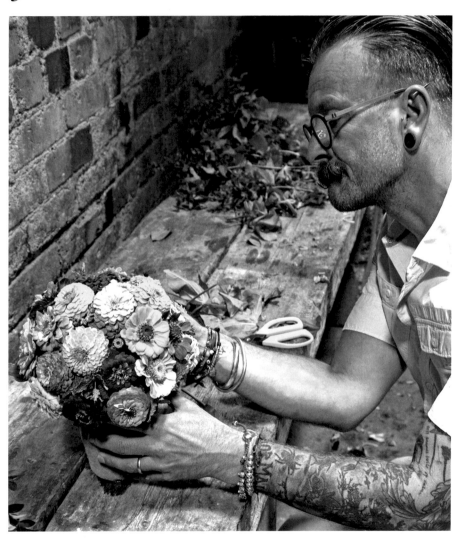

Continue adding flowers one at a time to form a pleasing and softly rounded silhouette. Use smaller flowers in amongst the larger ones and finally conceal any foam with a few remaining mint sprigs. Water well. Enjoy!

Massed marigolds

Bright orange African marigolds are an easy way to make a striking yet simple floral statement and we are fortunate to have buckets of them in the Flower Market from April to October. While it's useful to have availability all the year round for some flowers, to me, marigolds truly are a summer and late-summer speciality. I grow them in pots in my own garden and by July they start to look straggly and may well have succumbed to blackfly. My solution is to hack them back so that when I return from Scotland in September they reward such tough love with another delightful flush of flowers.

While they loathe flower foam, they are an easy 'arrange' in a small water-filled vase. All you need to do is strip off the lower leaves to keep the water fresher for longer.

This is all my own work – I actually created the vase in a ceramics evening class and it's a source of great satisfaction to me, as well as being a really handy size for simple 'plonks', like this mélange of marigolds.

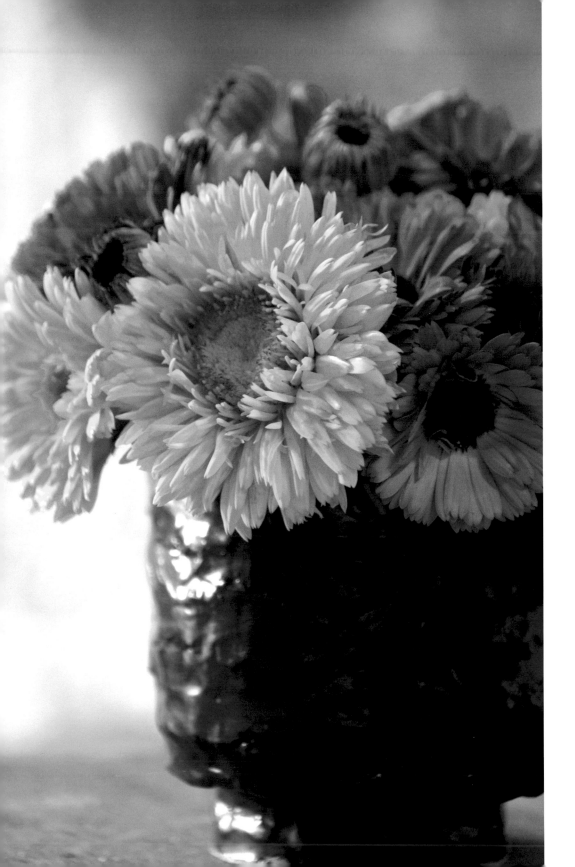

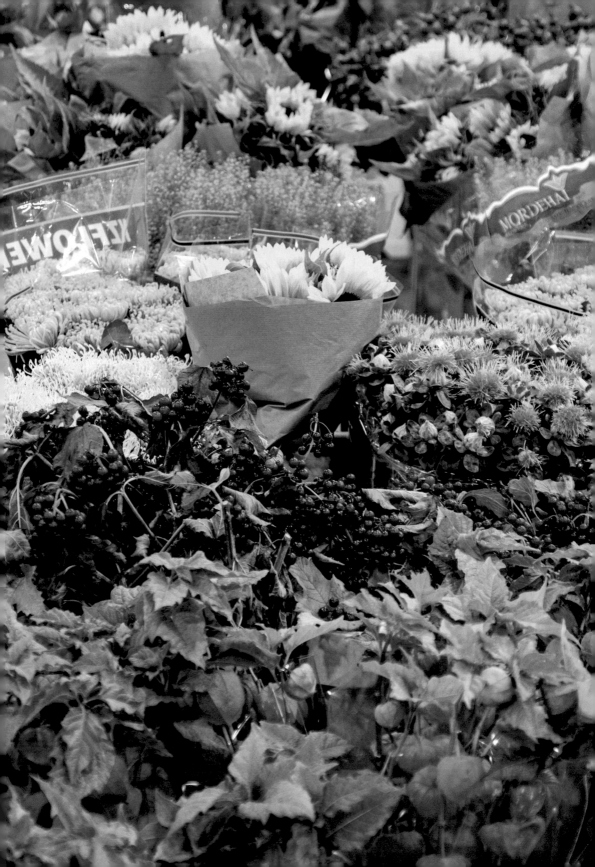

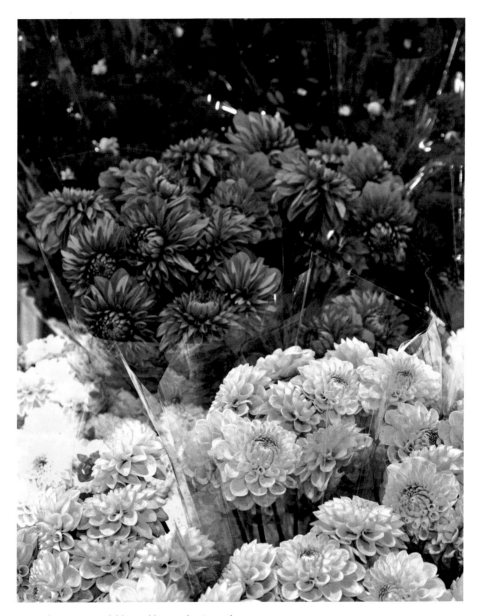

From glistening, jewel-like guelder-rose berries and lantern-like physalis pods to dahlias in a dazzling array of bright colours, the September Flower Market is a feast of textures as well as warm tones for as far as the eye can see.

October

T HE FOLIAGE STANDS, which always have some unexpected
excitements among their more regular selection, become
a trove of treasures as we head into autumn, and the palette of
much that is on offer swiftly switches from abundant greens to
a more tonal assortment of warmer hues. Trolleys laden with
bundles of British hydrangea flowers taking on antiqued tints rub
shoulders with trays of scarlet crab apples and boxes of brightly
coloured gourds. Crates of corncobs in a fantastic array of earthy
oranges and ochres, as well as the more usual yellow,

OPPOSITE *Early in the day,
the Market is awash with
subtle colour: the muted
autumnal palette of British
hydrangeas makes a perfect
combination with flat heads
of vintage pink-shaded
sedum and sheaves of green
and burgundy grasses, their
silky tassels adding textural
variety. Bursts of pink and
cerise nerines and spires
of gladiolus and kniphofia
punctuate the Market,
together with occasional
buckets of the last blue
scabious among cone-
shaped echinacea flowers.*
LEFT *By late morning, it
has all proved too attractive
to buyers – not much remains!*

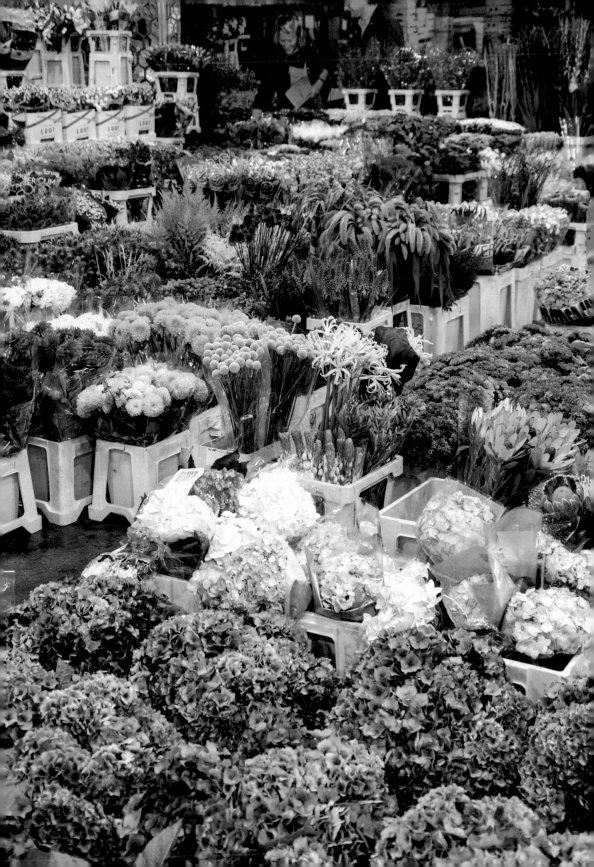

are stacked next to pumpkins piled in sizes ranging from footballs to Cinderella's carriage, in shades from EasyJet orange to more earthy Farrow & Ball.

Shallow buckets of compact sedum in dusky pink shades and pink-washed snowberry are lined up next to deep tubs of magnificent spindleberry, their distinctive bright pink berries splitting open to reveal startling orange seeds. It's at this time of year that armfuls of old man's beard and hop bines appear, hung from any handy nail, or swagged and swathed across a trolley. Tall bunches of silky-topped grasses and bundles of rusty-coloured dock seed-heads appear in fits and starts, dependent on what the weather is doing – useless and short-lived if overly wet, fabulous but fleeting if too dry! Sheaves of ripening corn and barley are welcome sights as are tall branches of hefty crab apples and spiteful yet elegant whips of rosehips. Great fat bunches of viburnum glistening with glacé-cherry-red berries stand next to stems of beetroot-coloured cotinus, their candy-floss-like smoky seed-heads tangling among teasels and branches of beechmast.

Inside the Market, the flower stands take on a more seasonal palette, as rows of buckets filled with fabulous physalis add splashes of bright orange among others draped with blood-red amaranthus and bundles of red and orange acer foliage. Buckets of bright sunflowers, pert echinacea and achillea add kicks of colour as do arching stems of flowering euphorbias, spires of gladiolus and broad wraps of Michaelmas daisies.

The British flower growers continue to wow, with asters and zinnias in a totally chaotic collection of colours, stacked next to neat boxes of belladonna and nerine flowers, their cerise and bubblegum-shaded flowers born aloft on slender stems. But the dominant seasonal treat at this time of the year are the boxes of dazzling 'bloom' chrysanthemums, in a rich assortment of shapes and colours, from pristine snowy white spheres to decadent balls of burnished bronze and curvaceous copper. To my mind they are one of the flowers that Britain still produces in far superior varieties to the Dutch. Sent to New Covent Garden

Among the flowers that many clients claim to loathe, the poor old chrysanthemum is high on the hit list. And yet the bunches and boxes of 'bloom' chrysanthemums, with 'incurve' and 'mop-head' varieties, look every inch as dramatic and spectacular as dahlias, which have seen a massive resurgence in popularity in the past few years. Hang on in there I say, the humble chrysanth's day will come!

from nurseries across the UK, they are laced into shallow boxes, with each flower spaced sufficiently apart from its neighbour to prevent the bevelled blooms becoming crushed. Like the dahlia, these favourites of my '70s' childhood are experiencing a social-media inspired revival, although for me, together with their less glamorous, multi-headed counterparts, chrysanthemums have always been a firm seasonal stalwart, their scent alone evoking chilly mornings and the sense of impending frosts.

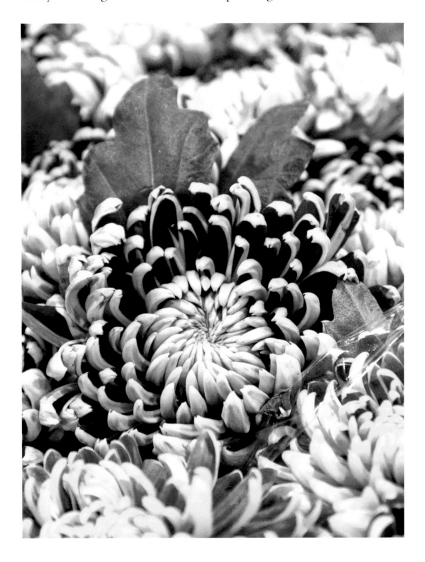

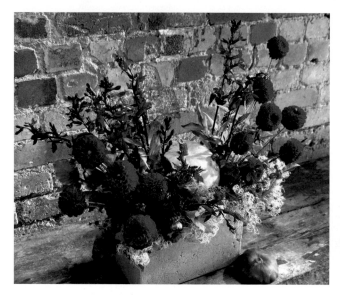

Pumpkin display

As an obsessive cook, I can be inspired by the appearance of fruit and
vegetables, and during October the Market will have a selection of trays
filled with apples and berries, punnets of mixed pods and seed-heads,
as well as trays and crates of gourds and pumpkins. While some are
purely ornamental, many are also edible, and within a box of mixed
squash I may well spy something that I know will be delicious to eat.
A concrete-grey Ironbark pumpkin grabbed my attention, not only
because I knew it would eventually make a glorious dish or two, but
also because its Farrow & Ball-coloured skin is a shade of grey that I
just love working with. For a few days after I snapped it up, it just sat
on my desk looking like a stylish curling stone and it was a toss-up
whether it just went home to the kitchen or I managed to make it into
an arrangement at all.

But as I was wandering past Zest, a stand that frequently has a
beautiful assortment of locally grown British flowers, I spotted among
the dahlias a couple of buckets of eye-popping bright red and scarlet
garden goodies and knew they would make the perfect foil for my
spectacular, concrete-coloured squash!

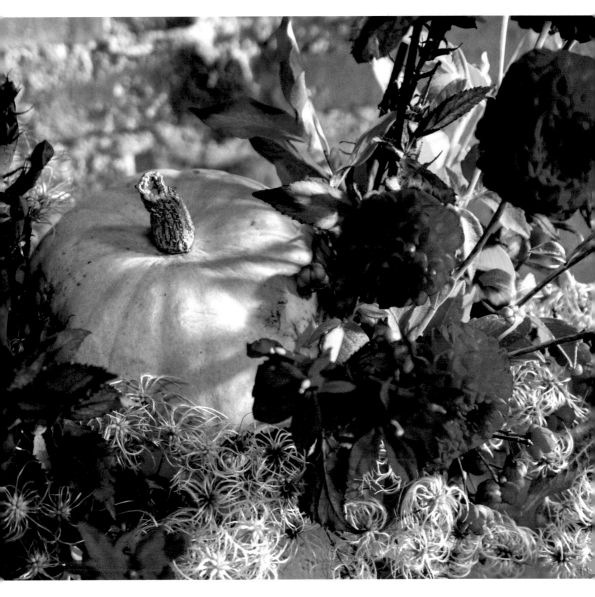

In October many of the British growers have been clearing their beds and borders in readiness for the frost and will gather and bunch up everything they have hacked back from the summer's excessive growth. I spotted just such a bucket, with stems of pert penstemon and incredibly vivid salvia among some bright pompom dahlias. Combined with a few snaffled stems of old man's beard and a sprig of surprisingly lurid spindleberry, they were the perfect counterpoint to the visual weight of the concrete slab container and, of course, my prized Ironbark pumpkin.

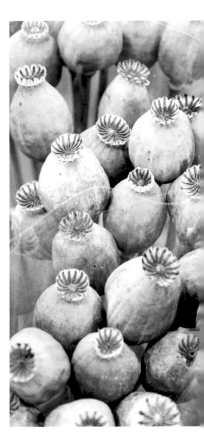

Just when I'm in need of a rest from the overwhelming orange and burnt umber hues that dominate the Flower Market in October, I'll come across a trolley laden with ornamental cabbages, their decadently frilly leaves edged in purples, pinks, mauves and creams in dazzling contrast to the dark cast across their leaves. These glamorous distant cousins (OPPOSITE AND ABOVE CENTRE) *of the Savoy cabbage and the Brussels sprout thrive as growing plants in window-boxes across the capital, and are also sold as cut 'flowers' too. Contrasting snake grass* (ABOVE LEFT) *and poppy seed-heads* (ABOVE RIGHT) *give an oft-needed moment of verdant green during this autumnal era.*

Stems of flowers as fine and detailed as these scabious and nerines really need very little intervention to become almost jewel-like in their stylish simplicity. I used my hand as a vase, gathering and arranging them into a modest posy-style silhouette before securing the stems with a rubber band. Cut to fit a pair of mismatched marble beakers, they create a textural treat.

Pretty in pink

Although the Market in October is dominated by autumnal hues, it still has an abundance of other colours, and a stalwart of the late-summer flowers is the nerine. Many years ago when I worked at Pulbrook & Gould, they had a network of rather grand ladies who would arrive in scruffy estate cars, the boots crammed with buckets and bowls filled with foliage and flowers gathered from gardens one could only dream of. As a very lowly junior, I marvelled at what might be dragged from these cars and deposited upon the pavement, and wanted to know exactly where it had all come from. I never dared to ask, so imagined the herbaceous borders of old rectories in Wiltshire and honey-coloured Cotswold dower houses that might have given up such gorgeousness.

Among the bundles of garden roses and bright buckets of jewel-coloured dahlias, the surprise would be the sleek and slender wands of nerines. It seemed remarkable then, and still amazes me now, how their pencil-point, green-sheathed stems can explode into a fabulous firework of a flower in a magical palette of pink and cerise, white and blush, mauve and magenta. Some even appear to have glitter smeared along their petals, iridescent in a certain light. They truly are a seasonal treat: a final farewell to the soft shades of summer.

November

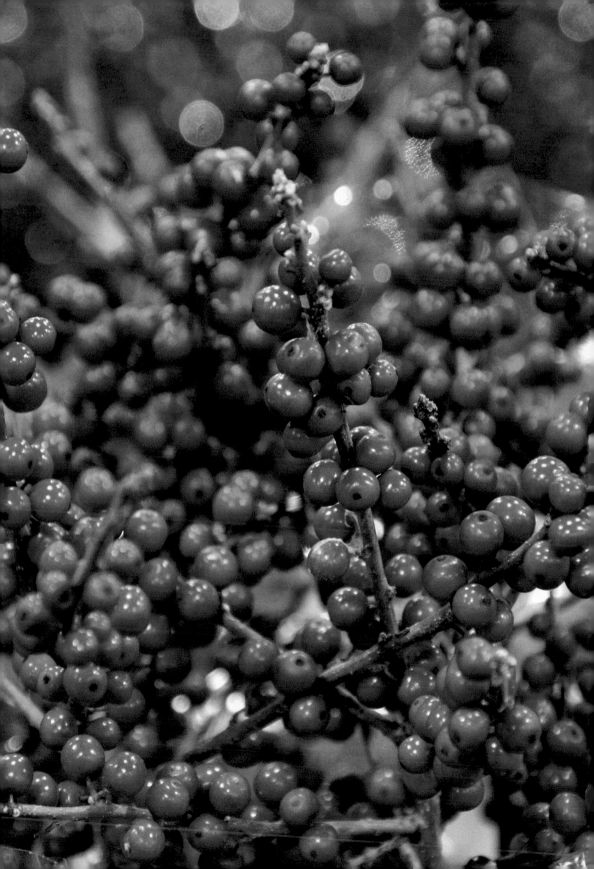

CHRISTMAS NOW APPEARS TO EXTEND from the moment
Halloween finishes until at least Boxing Day, and to me the
prospect of spending almost two months among baubles growing
dull with dust and pine slowly drying to brittle tinder takes away
all its anticipatory magic. Whatever must it be like attempting to
sustain the momentum of apprehension and anticipation among
small children?

While I understand most businesses wish to maximize the
festive season's financial opportunities, I am fortunate that,
having no retail outlet, we don't have to immerse ourselves
totally with the tinsel and glitter full-time, merely dipping in
and out at our clients' behest. So for me, November becomes
a month that fills itself with their seasonal entertaining – with

By November, Christmas begins to take over the Flower Market, the flower stalls laden with red-shaded everything, much of it with 'festive' add-ons, such as faux snow and sparkles for seasonal allure. Nowhere, however, becomes quite such a glitter-fest as the foliage stands, where trees 20ft/6m tall are lacquered in every imaginable colour and drenched in a dazzling assortment of glitter, from almost subtle iridescent to out-and-out, blingtastic blue, cerise and red.

dinners and weddings as well as bar and bat mitzvahs. Frequently
the workroom contains a surreal mélange of amaryllis, pine and
cinnamon sticks, contrasting with vivid pink, butterfly-covered
vases of ombré roses, or steel frames suspended with wine-gum
coloured perspex shards atop slabs of Rubik's-cube shaded
carnations. Certainly from Bonfire Night onwards, bundles
of blue pine become a regular feature within the cool, damp
doorway of Lycett Towers. Vast stacks of bauble-filled boxes
are exhumed from the darkest recesses of our sprawling railway

*Who knew that nothing
said Christmas like a
slice of dried loofah? I
was pretty surprised to
spy these sections of dried
loofah, among bundles of
cinnamon sticks and pine
cones, already mounted
upon wires, ready for
wreaths. History doesn't
relate how many dried
loofah slices were ever sold!*

arches, and stacked upon trolleys, labelled with porn-star-like names such as Sequin Bells, Fluffy Snowflakes and Glitter Robins.

While some clients want garlands of pine, wreaths of berries and evergreen foliage, others anticipate a season-cheating summer-fest of flowers for wintry weddings that defy the date. Although I am not a personal fan of out-of-season blooms, they certainly make life much easier in the world where the client is king, and where for some the need to be married among clouds of hydrangeas and radiant roses is unabated by the seasons.

Thankfully the clever Colombians and Eucadorians, as well as the Kenyans, grow wonderful roses and hydrangeas, and especially glorious scented garden roses that, with modern transportation links, can be flown a few thousand miles to appear into Market as fresh as any that have been garden-gathered in the UK during the summer months. I was fortunate to visit Kenya for a TV documentary a few years ago and saw the expertise and passion with which these flowers are nurtured, tended, harvested and packed, with all the care of a donor organ, prior to being shipped to Holland where they are slowly rehydrated before being sent off to flower markets around the whole of Europe and beyond. While flower-miles continue to be controversial, recent research seems to conclude that producing flowers in a country where they thrive with relative ease, and then flying them into Europe, is still less harmful to the environment than heating acres of hothouses to produce flowers in Northern Europe out of season and shipping them a shorter distance. In addition, the flower farmers in such far-flung countries can create wealth and employment opportunities for communities where living conditions are otherwise challenging and tough.

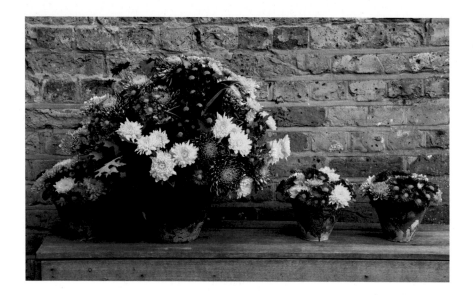

Chrysanthemum pots

During November, while the world seems to slowly become embedded in sparkle and all things festive, it can be a real treat to create something that has absolutely no Christmas resonance at all. This feast of seasonal flowers is a perfect counterpoint to the glitter and bling, as its mixture of assorted British-grown chrysanthemums has just a few stems of magnificent *Magnolia grandiflora* leaves arranged among them to give some textural variety. This is a favourite variety of mine, with its glossy British racing green leaves that have suede-like brown undersides. The entire decoration sits in an old Italian terracotta resin-collecting pot, still sticky with sap, concealing a watertight bowl and a showercap of chicken wire (like the one shown on page 57) supporting it all.

Creating smaller 'satellite' arrangements in coordinating containers in exactly the same manner as the main one is a lovely way to add unity to your decorations, making more of a statement than an individual arrangement would but without becoming too much.

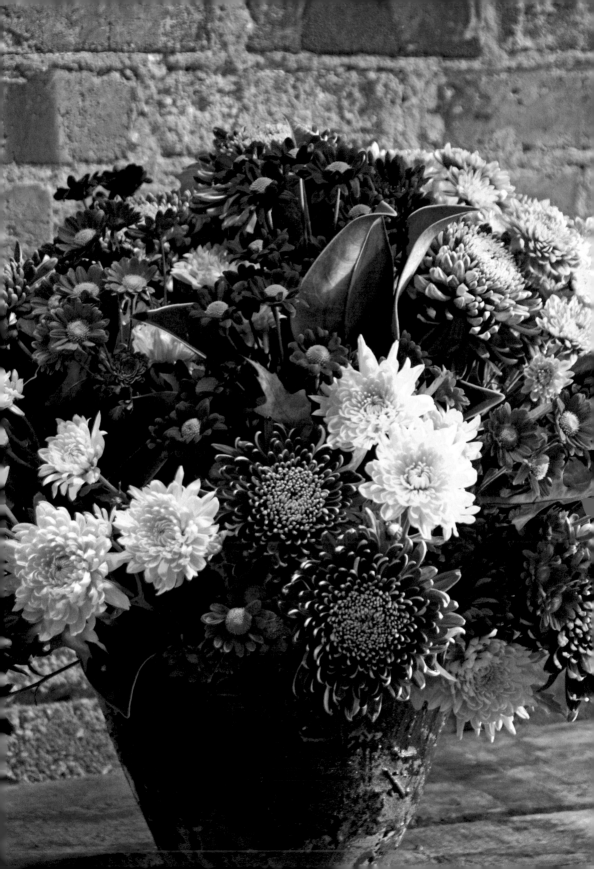

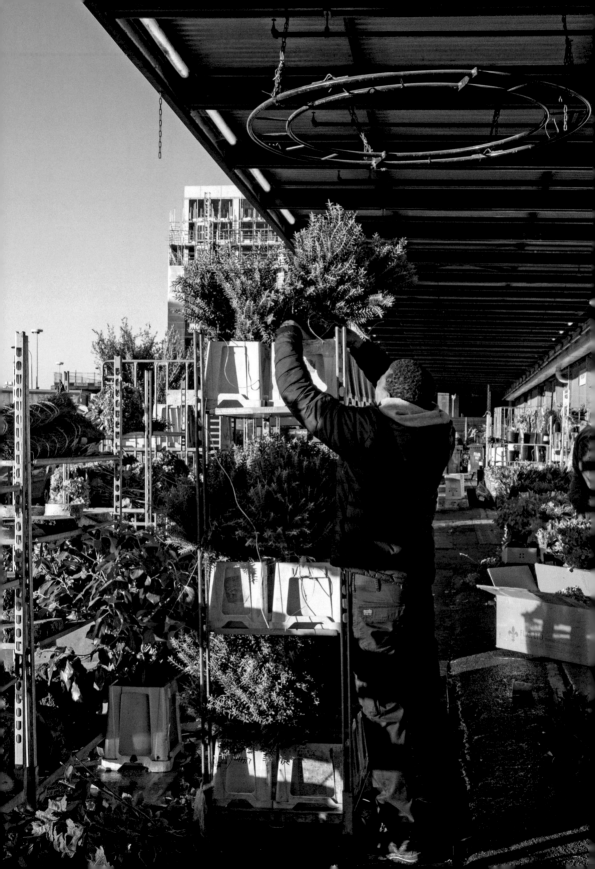

*The low autumnal morning sun casts its rays across trolleys loaded with
assorted British-gathered greenery* (OPPOSITE). *We are so lucky that
there are stands in the Market that specialize in foliage from across the
globe but, in particular, home-grown varieties, ranging from bunches of
berried ivy to crab-apple-encrusted boughs* (ABOVE) *and trays of mosses.*

*As November ticks along, it often feels as if the entire world
is tinsel-wrapped, so it's wonderfully refreshing to occasionally
happen upon a few buckets of late-autumnal foliage, fruits and
berries, unadulterated by glitter, and all the more magnificent for
that! These more muted finds work brilliantly well when arranged
with pine and holly, in juxtaposition with the more usual
Christmas-fest of red and of gold.*
ABOVE *(from left to right) The orange tones of rosehips and
physalis, porcelain white snowberries and flask-shaped orange hips
of Rugosa roses, along with pink-blushed crocosmia seed-heads,
all combine with pine for a more understated festive flourish.*

December

B Y THE START OF DECEMBER there is no escaping the 'C'
word, with virtually every event being at least 'seasonal' or
'wintertide' (to eliminate potential offence in our multicultural
world) and our time is spent creating decorations and designs for
Christmas lunches, dinners and parties. The trolleys of baubles
in the corridors now look well-plundered and sit, like tired drag
queens, spilling sparkling glitter and shimmering beads, and
dangling trails of sequins and stars, tinsel and feathers.

Throughout the workroom, the endless battle with
amaryllis buds continues. Buckets are placed on every surface as
these seasonal stalwarts slowly start to develop from uninspiring
sticks into trumpets of velvety voluptuousness. They look
magnificent when, like tannoy speakers, the flowers unfurl
but are underwhelming in the extreme if not fully open. I
spend half my time irritating my brilliant team, questioning

*While across the year the
Flower Market is mostly
filled with myriad colours
and varieties of flowers and
plants, during December
there is a strange form
of unity and cohesion as
everyone vies for sales, be it
the sundries stands which
suddenly have vast pots
perfect for huge Christmas
trees – or even people in
festive mood (LEFT) – and
plant stands loaded up with
poinsettias in every size
and hue (OPPOSITE).*

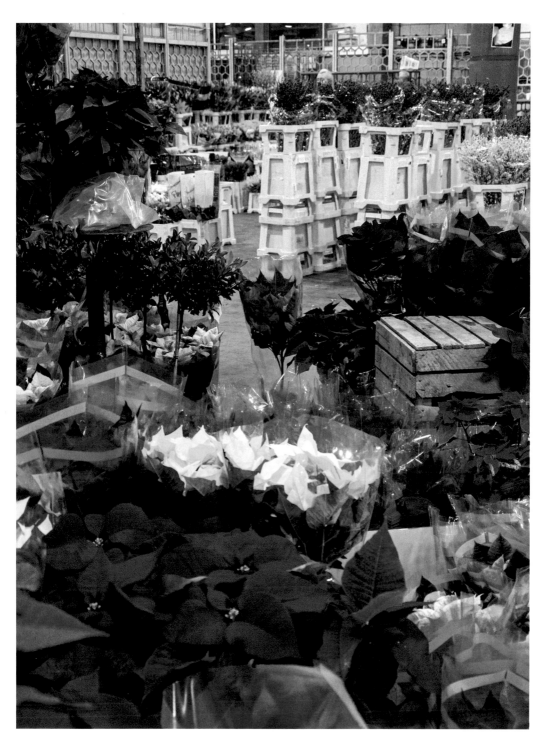

whether the buckets need to be either cosseted in the warmth of my office to bring them on or cooled down to arrest further opening. As always, having flowers at an optimum level of 'openness' is key to the look we achieve, as our decorations rarely need to last longer than the finite few hours of an event. This means we need to make sure every bloom is as big and bold, and as elegant and on-point, as it can be, so each stem sings for its supper in full voice. Amaryllis, along with lilies and paeonies, are the most challenging of flowers, for sometimes they will steadfastly sit and stare back at us, tight-budded, for days on end, while at other times within a few hours a once-green bucket transforms itself into a sea of colour. One of the greatest skills my team possess is being able to assess and 'read' the flower and plant material as it arrives daily from the Flower Market, deciding which gets the cold shoulder and remains in the ever-cool, if not downright-chilly, workroom and which are destined for a warm bath and a session in the offices, where radiators and lights entice them into opening earlier than they might have wished so to do.

OPPOSITE *Bundles of berry-laden holly await those buyers prepared to run the gauntlet of their staff to create traditional garlands of this prickly evergreen, alongside crates of mistletoe gathered from the orchards of Worcestershire.*
BELOW *Bunches of ilex berries, the branches heavy with glistening, jewel-like fruits.*

For much of the year the demand for plant material is shared across a really broad spectrum of varieties, types and colours, but for much of November and pretty much all of December, the whole of the western world, plus large tracts of Latin America and beyond, is focused on a fairly prescribed palette of colours and a pretty limited selection of stems. While the growers gamely attempt to entice us into wanting red tulips and glitter-ball-adorned gerberas, most clients still wish to see the rich redness of amaryllis and roses, with pine and ilex berries adding to the fairly limited festive wish-list. For this reason, demand sometimes outstrips supply and in anticipation of this, some stems are stockpiled and cold-stored in Holland, as growers experiencing a bit of a glut will hope to take advantage of the higher prices

that increased demand will bring. While a few days will not
adversely affect amaryllis or roses, some occasionally slip in
among freshly harvested stems, and frequently, as each flower
slowly unfurls, the papery blooms of over-refrigerated flowers
reveal themselves, not only by prematurely peaking but also
by the poorer quality of their flowers. These we weed out and
substitute with fresher counterparts.

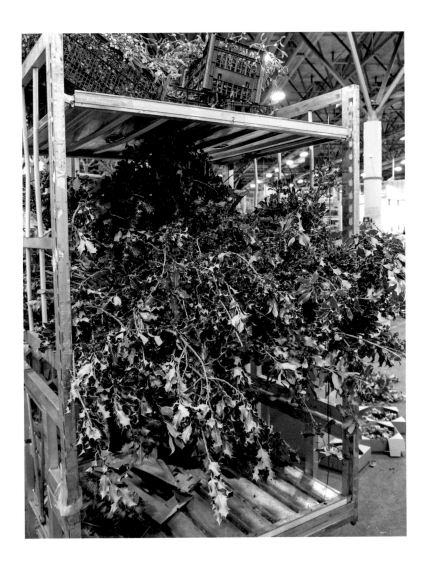

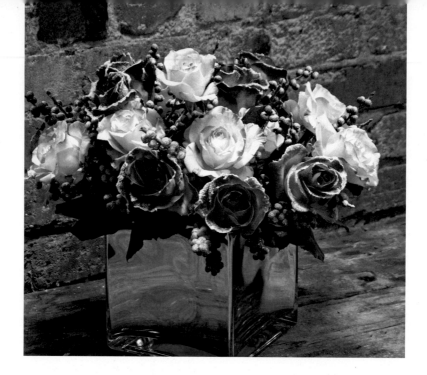

Frosted rose and berry

Canny Dutch wholesalers are always looking for ways to add 'Buy me' appeal to flowers in varieties and colours which wouldn't be the first choice at certain times of the year, so as Easter approaches tiny yellow chicks are impaled in the middles of bright burgundy orchids and during December the non-festive shades of flowers are occasionally given a frosty makeover. These vivid pink roses with their Jack Frost flourish caught my eye, and when made into a tied posy with some stems of ice-encrusted ilex berries, created an unexpectedly pleasing arrangement perfect for any winter celebration. It's possible to recreate your own frost effect on flowers by wafting a spot of spray glue gently across a semi-open bloom before sprinkling it with faux snow or glitter. We try to always use an edible or plastic-free variety of glitter (to avoid adding any more unnecessary microplastics into the world). Another technique is to use fine pins to impale a sparkling bead or tiny bauble or two within the centre of the flower or a hot-glue gun to add a few shimmering beads with natural berries for a contrasting kick of colour.

It's Christmas, so what better excuse to put unrelenting good taste to one side and have a bit of flowery, festive fun? Often the less Christmassy colours (anything that isn't red!) are less costly as the demand is less, so bargains can be had. With a bit of imagination and a sprinkling of snow, they become as festive as Father Christmas himself.

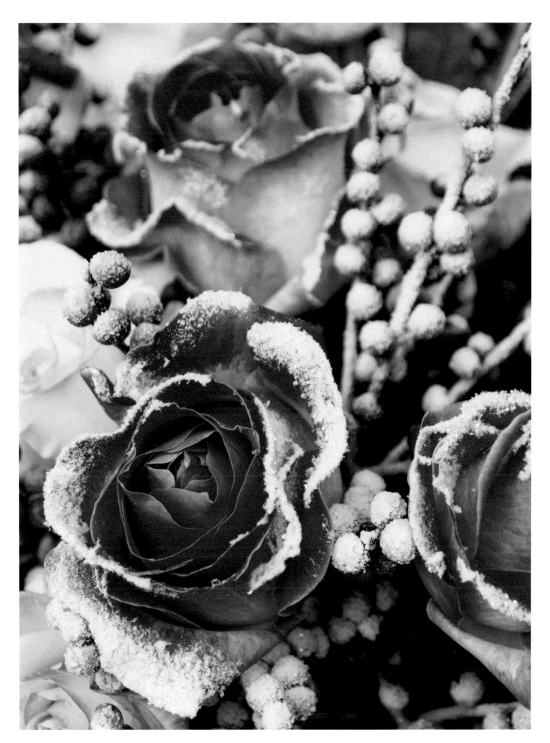

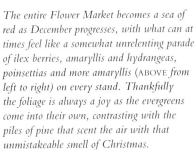

The entire Flower Market becomes a sea of
red as December progresses, with what can at
times feel like a somewhat unrelenting parade
of ilex berries, amaryllis and hydrangeas,
poinsettias and more amaryllis (ABOVE from
left to right) on every stand. Thankfully
the foliage is always a joy as the evergreens
come into their own, contrasting with the
piles of pine that scent the air with that
unmistakeable smell of Christmas.

Cool Christmas wreath

While our 'house' style is generally exceedingly abundant, OTT and fulsome, and no more so than at Christmas, by the time December actually arrives I sometimes yearn for a more restrained, pared-back design that can make just as much of a statement. The design for this wreath came about because the colour of the wonderfully wide silk ribbon caught my eye as I wandered around one of the sundries wholesalers early in December. It was hidden near the back of the shelf and was also eye-wateringly expensive, so one roll had to suffice! Minutes later, clusters of marble-sized glass baubles, already wired and in glorious gunmetal grey, took my fancy and, with a tray of pine cones lacquered in what the wholesaler rather grandly called 'rose champagne', I had found a minimal but pleasing palette of colours which, with sprigs of blue pine to unify them, would create a suitably on-trend Christmas wreath without requiring the usual vanful of sparkles and stars, baubles and bling.

Back when the practice was still legal in the workplace, this was the Smokers' Bench in my workshop. It remains in position, but now doubles up as dumping ground for works-in-progress when the workroom is overflowing, and, in quieter times, suitably pimped with pillows, lanterns and vases of 'something seasonally exciting', serves to give my clients a reassuringly curated first impression when they arrive at our workshops. In reality, these are a series of scruffy railway arches, fondly referred to as Lycett Towers! Occasionally I even get to sit and have a cuppa there, collecting my thoughts and realizing how lucky I am to still love something I have been doing for more than 30 years.

1

Assemble your main decorative wreath materials (pine fronds, pine cones and baubles and a good length of ribbon (about 2m/6ft long) plus a wire wreath frame, damp sphagnum moss, fine reel wire and heavy-gauge florist's stub wires.

2

Tease out the moss. Secure the end of the reel wire to your frame and bind a handful of moss onto the frame. Butt the next handful up against the first and bind into place.

6

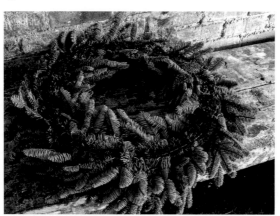

Once the frame is completely covered, top and sides, cast off the reel wire by twisting it onto the wreath frame before snipping. Step back and check the wreath has a circular shape and the central opening is clearly visible.

7

Pre-wire the pine cones by holding the wire at both ends and pushing the centre into the cone base, and then twisting the ends to form a prong.

3

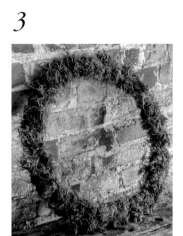

Continue until the wire frame is totally concealed and the density is even, as it is the base to which everything will be secured. Cut off the reel wire and trim the moss with scissors to neaten.

4

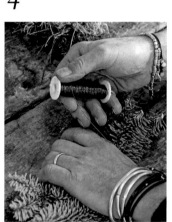

Cut the pine into smaller sprigs between the side stems. Attach reel wire to the mossed frame and lay pine sprigs on the moss. Bind into place.

5

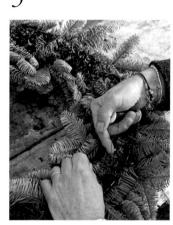

Make sure the next sprigs cover the stems of the first. Bind again. Continue around the frame.

8

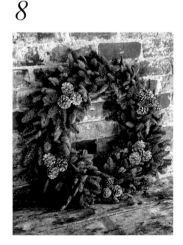

Attach each wired cone through the base, pulling it firmly into place, bending the end and pushing it back into the moss. Check the balance.

9

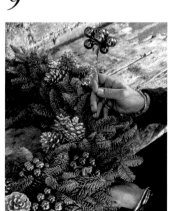

Add in other decoration as with the pine cones, from front to back and returning the wire ends on the reverse into the mossed base.

10

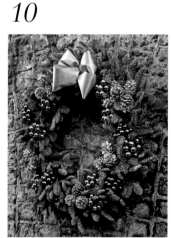

Finally, add your ribbon bow, top or bottom (12 o'clock or 6 o'clock) anchored in place with a florist's stub wire. Add a hanging loop. Et voilà!

191

Epilogue

The Flower Market move has now happened, and I am buying my flowers from the same folk who served me in 1987, just in a much shinier and brighter building, where although the loos are cleaner, the sense of the place is slightly diminished! However, this interim home is fine, and in a few more years a further move will be made to what will become the New, New Covent Garden Flower Market, where it thrills me to think that the sights and the scents will still entice and excite, and also evoke the magical moment in my life when I truly fell in love with flowers, and with being a florist, and where the seasons will continue to turn, their progression marked by the trays and boxes, the buckets of beautiful blooms and the bundles of foliage and flowers.

Acknowledgments

First and foremost, I am so grateful to Michelle Garrett, my photographer, for all she did, as this truly is for me a magnificent moment, perfectly preserved, a definite step in the timeline of my life as a florist. Her calm and quiet capture of the flowers and of the characters who make the Flower Market such a unique place was all and more than I could have imagined.

To Susan Berry, who for 25 years has been my editor on every book I have written – the constant among a plethora of publishers, which alone speaks volumes (pun intended). Self-publishing this book through her has been a wonderfully enjoyable exercise. She has guided the project with consideration at every stage and I am truly grateful to her and to her proof reader, Sue Cleave. Through Susan, firstly Ed Berry for the initial design concept and then Steven Wooster for transforming my vague suggestions and a year's photography into a gloriously succinct, visual feast of seasonal splendour with wit and skilful vision.

Whilst I have been able to immerse myself over the past 18 months in this project, Team Lycett have continued to work tirelessly on events across the world. The devotion, enthusiasm, loyalty and humour with which

they greet every one of my never-ending demands is testament to what a talented and lovely group of individuals they are, who together could, can and do make magic happen. From amazing arranging and incredible administration, in the workroom or the office, each of you is as vital as the next. I am lucky and grateful, and I thank each and every one of you for sharing your time and your talents with me.

Across the 30 years that I have been buying from the Market, characters have come and gone, unique friendships and alliances have been forged. I remember with gratitude and thanks those who are no longer with us, but who become threads woven into the weft of the place and I acknowledge here the incredible men and women who now make up New Covent Garden Flower Market, the salesfolk and the porters, the wholesalers and my fellow florists. I thank you for being generous enough to have allowed me to capture and preserve a snapshot at a time when uncertainty and change was challenging us all.

And finally to my husband, the one steadfast in my life, who continues to be the still, small voice of calm. Always. Thank you. I love you.

To share more of my flower-filled world, with daily doses of floral fabulousness, follow me on

 @simonlycett